Toward
the Transformation
of Art

Justin Schorr

Rutherford ● Madison ● Teaneck
Fairleigh Dickinson University Press
London: Associated University Presses

© 1974 by Associated University Presses, Inc.

Associated University Presses, Inc.
Cranbury, New Jersey 08512

Associated University Presses
108 New Bond Street
London W1Y OQX, England

Library of Congress Cataloging in Publication Data

Schorr, Justin, 1928-
 Toward the transformation of art.

 Bibliography: p.
 1. Arts, Modern—20th century. 2. Aesthetics,
Modern—20th century, 3. Arts and society. I. Title.
NX458.S36 701'.1 73-8298
ISBN 0-8386-1382-9

Contents

Preface

Revolution or Transformation

When Steve Reich suspends a number of microphones above corresponding loudspeakers, sets them swinging like pendulums, and amplifies their sound pick-up so that feedback noise is produced—that's art.

When Andy Warhol published the unedited transcript of 24 hours of taped conversation—that's art.

When Walter De Maria fills a room full of dirt—that's art.

We know they are art, obviously, because a concert announcement, a title on a book jacket and an art gallery say so.

—Allen Kaprow,
Art News (Feb. 1971), p. 29.

Obviously it is no longer important who is or is not a good artist; the only sensible question is—as is already grasped by some young people—why isn't everybody an artist?

—Jack Burnham
Problems of Criticism IX,
Artforum (Jan. 1971), p. 45.

Art—its practice, theory, and performance in life—is now undergoing a radical change-phenomenon, one that is, we shall see, of sufficient scope, depth, and impact to be called a revolution. That revolution is constituted of and advanced by several specific developments in form, philosophy, and conduct, and this book attempts to discern

and display the revolution in art and the parts of which it is made.

But this book is also and more emphatically about the changes that should be occurring and about how one may work toward achieving these. For the revolution and the transformation really needed are not identical.

The shape and meaning of the phenomenon currently altering art will emerge fully only through the course of our discussion, but it is easy to see at once that several radical changes are in fact occurring and to note what they are. In the area of art form, for several years now we have been getting developments—Happenings, Earthworks, aleatoric art, process art, to name a few—that evidently are unrelated to those interests in style, content, and structure which previously intrigued artists. In fact, the new forms often appear so unrelated to all that people usually mean by art and artistry that they are sometimes called anti- or nonart. But whatever one calls them, they evidently are deviations from tradition in art form.

Also apparently changing are the personal attitudes of citizens of the realm toward art. One may see, for example, art students wearing buttons reading "Art is all over"[1] (Finished? Everywhere? Both?). And one may see Phillip Simkin distributing to fellow artists and art teachers stickers reading "Curb the urge to make a mark."[2] One may note hundreds of prospective and one-time artists verbally damning the high arts and abandoning them in favor of artisanship, farming, or other workaday occupations. And one may hear or read anti-high art statements by people well known and well placed in the art world, statements by such as artist-activist Robert Morris, critic-theorist Jack Burnham, and anthologist-critic Gregory Battcock.[3] Of course, some rebellious, critical, and disturbed conduct is not unusual in my field, the field of art, but these occurrences may, I think, still be regarded as evidence of change in art people's attitudes.

Also evidencing change in art theory are some of the

statements now coming from philosophical writers on art. Heretofore, their essays usually were to explicate, rationalize, and account for artistic and aesthetic phenomena, and they were full of respect for their subject. But now we get blame from Herbert Marcuse, who views art (with ambivalence) as supportive of a bad society; and we get doubt from Morris Weitz, who finds the concept *art* apparently undefinable and probably without specific content, and we get incredulity from Morse Peckham, who alleges that art is only what judging elites say it is—quite without respect to any sound foundation for their decisions. Surely it is unusual to have such aspersions cast upon art. Practice in the area of art theory is apparently also changing.

It would seem that art as a whole—its very meaning and mode of being—is undergoing change, and this not only to the extent revealed in the above instances. To see what the art enterprise is undergoing, one must, I think, see the above-named (and other related) developments not just individually and as singular deviations from the usual in its area, each making its own specific changes, but rather as each in part coinciding and concurring with the other developments, to form, in their overlap, a large counterflow phenomenon. It is the existence and effect of this counterflow that is pervading and reshaping art. True, the specific developments have each their own progenitors, premises, generative causes, and aims, but each is yielding results that, although also very variegated, in part overlap those of the other developments, which overlap constitutes strong, effective, and evident opposition to our usual art practices and beliefs. To see this in a microcosmic example, a work by Robert Morris, an essay of Herbert Marcuse, an option for farming of a former art student, each generated by and expressive of many different things, all coincide in (and perhaps only in) being against high art; and in the density of their overlap they constitute something stronger than each could alone. Taken together, and oft-repeated, they

constitute an anti-high art component of the large change-phenomenon now affecting our world of interest.

Because I want to reveal that this phenomenon is in fact occurring and to discern what it is and why it is, I will herein regard the several specific change-provoking developments as somewhat coinciding, with attention to where they coincide.

Further indications of the substantiality of the changes I cite, and of their character, come from noting that they overlap a still larger phenomenon, whose reality and nature are well known—the counterculture. Both the changes in art and the efforts of the counterculture have, it is true, some trivial and fast-fading manifestations, but both also have, and have in common some persisting beliefs, attitudes, and traits that are well founded and generative of new forms. Both share, for instance, some of Herbert Marcuse's thinking and certain ecological concerns, factors of considerable and continuing influence. And both evidence a common spirit—anti-elitist, antagonistic to the Establishment's repressiveness and pecuniary values, and apparently desirous of making art and life one. To see this overlap in practice, we need only look at how large are the aesthetic aspects of countercultural manifestations, the role in them of the crafts and sensory development, the evident interest in relating life- and work-processes to materials and goals in ways like those occurring in art. Our art developments coincide in part with this other evidently important phenomenon, and their reality and character are emphasized thereby.

I think that, to avoid repetition of long clumsy phrases, and without great inaccuracy, we may call the phenomenon of change in the art field *the revolution*. True, the term is grandiose and overworked, but perhaps it may still be used to comprehend widespread radical alterations in an area of life, used as I employ it here in common nonpolitical parlance to characterize the aforementioned counterculture as a revolution. So employed, it suggests no actual co-laboring

toward mutually held goals, nor even communication between comrades, but only the yield of a radical opposition and of effective and deep alteration in the area of art—which is what we indeed have. This revolution is a major concern in the pages below.

To one who has long argued that our beliefs about, and actions in, art should be altered radically, the revolution poses a problem. The changes made in and by it are a very mixed bag, hence not to be endorsed or rejected *in toto*. In some revolutionary developments, good and bad things are destroyed together. Sometimes the best and worst of reasons generate, and are expressed in, the changes. Sometimes only a new attitude is realized, implemented by nothing that can work to any good end. Sometimes things that evidently ought to be considered and done have not even been thought about. One must therefore feel ambivalent about, and unsatisfied by, the revolution; or he may go further and try to cull out the bad in it, leave the good standing, offer alternatives and additions where necessary, and all in all try to present ideas and actions, extant and newly proposed, effective for getting really desirable results. This last is my intent and procedure herein, to conduce to the kind of change I think of as a radical transformation of art.

Specifically, what I offer next is a display of the revolution (chapter 1). This is a presentation of the cited forms, acts, and essays, not in all their fullness of background and meaning, but rather in a rendition of those aspects which run counter to the current in my area of interest, the aspects in which they are, from my viewpoint, revolutionary. My presentation includes discussion of developments that bring forth, among other things, attacks upon high art and the art world, and that produce the claim that new arts, life-styles, and art-life relationships are mandatory.

Then is rendered the major part of my response to the revolution (chapter 2). It leaves some of the revolution's endeavors standing—even endorsed and amplified, but it

attempts to defeat or transform others. In some areas I present a new pattern of thought, because it is necessary, irrespective of the fact that the revolution does not open the issue involved. We may conclude from these discussions that, for one thing, the attack upon the high art is defeatable and that the high arts may endure *if* both our thinking about them and the environment for them are changed as suggested herein. We will see virtues in high art *and* in revolutionary, extended, aesthetic practices. Indeed, emerging from this chapter is the major portion of a way of thinking that enables us to consider the various old and new art-act options and art-life relationships justly—that is, with appreciation of their merits and faults and without undue theoretic privilege to any.

But because action toward, not just thinking about, change is necessary if alterations are to take place, in chapter 3 suggestions are made for endeavors we can undertake to work toward desirable conditions in the areas of our concern. Additional new views are revealed in these recommendations. Out of this will come, I hope, some theoretical and practical aid toward achieving those changes in art thinking, practice, and performance in life which are in fact needed.

To avoid misunderstandings: one should not expect to find herein a history of any form or philosophy, nor a vivid description of it, nor a rendition of its full meaning. Each development grows out of more than I will note, results in more than I will say, means more than I will mention. I will only seek out and refer to those aspects of the form, act, or essay which overlap with others to make the countering development that interests us. These overlaps are really there, but they are not all that is there, and lest my discussions be taken as unjust to the things they mention, it is well that my limited intentions and claims be noted.

Neither is this volume a survey of all of our revolution's art forms, nor an *aesthetic* critique of any of them. Listing them in great numbers and judging any one's aesthetic

merits is not the point, for it is in some of the attitudes and ideas expressed in and made real by the forms that the revolution resides. One need not cite many forms (or have many in the world) to make the ideas and attitudes actual and clear. The aesthetic worth of the forms, great or small, is not identical with the form's position, which is my center of focus. Some few art forms are here cited as illustrations and actualizations of attitudes and beliefs, no more.

The determination of historical fact is not my concern here; respect for fact is, so I will not try to say definitively whether the theoretical statements examined are indeed interactive with the forms I mention. The several artistic and theoretic developments here mentioned evince a potential for influence upon, and service to, each other, for mutual aid in achieving their somewhat common results, and it seems likely that these potentials are sometimes realized—after all, artists do read and writers do look at art—but I am not concerned with determining whether such aid was historically realized or not. I have said that the results of the several developments aid each other by overlapping; I will not judge whether they communicated or colluded to assure the overlap.

By the end of this discussion of these revolutionary developments, a stand and position will have been rendered; the attitudes and ideas visible in the overlap of the developments noted will have been laid out. But because this display is my construction, it is highly unlikely that a person now exists who holds precisely this set of attitudes and ideas. Yet, it would be convenient to talk as if such a person existed, one who held this revolutionary viewpoint and none other, and who therein would be the revolution's spokesman. For convenience, then, let me engage in personification and create "the revolutionist," he who would exist if the countering phenomenon mentioned were to write its "party line" and appoint its advocate. But let it be understood that the people discussed below are not this fictive character; they are each more and other than "the

revolutionist," though parts of their works go to form his position.

As a final clarification: one will gather that when the high or fine arts are referred to, the references will be largely restricted to those arts one associates with galleries and museums rather than those one associates with recital and concert halls, publishers, libraries, theaters, and the like. The new form-possibilities I discuss most often are those originating in the museum-gallery world and still discussed in its journals, even when these forms seem uncontainable by that world. Other forms (e.g., street theater) coming out of other art realms or the counterculture are recognized but seldom referred to. The most frequent reference within the high arts involves the art of painting, partly because as a painter and teacher of this art I know it best, and partly because it serves well as ground for the conflicts we face.

Toward
the Transformation
of Art

It is therefore my personal opinion that almost
all avant-garde forms of the twentieth century
are transitional in a special sense. Obviously
all art is in transition, as is life itself.
But the ear cleaning and eye washing that is
now going on in the concert halls, galleries
and museums is in preparation for a return to
the inseparability of art and everyday life.
The paintings are vanishing into the walls; but
they will be marvelous walls. In turn the walls
will vanish into the landscape; but the view
will be ecstatic. And after that the viewer
will vanish into the view.

—Alan Watts
Does It Matter,
(New York: Random House, 1970),
p. 115.

1
Presenting the Revolution

It seems a truism at this point that the static, portable, indoor art object can do no more than carry a decorative load that becomes increasingly uninteresting.

—Robert Morris
"The Art of Existence:
Three Extra-Visual Artists,"
Artforum (Jan. 1971), p. 28.

I think art can be anything. We make up the word and we use it and apply it. It really depends on what we apply it to. It's a matter of who you convince and who comes to see it your way. If it's someone in a position of identifying what is art, then what you're doing becomes art.

—Cindy Nemser, quoting the artist in
"An Interview with Stephen
Kaltenback," *Artforum*
(Nov. 1970), p. 52.

The Shape of the Revolution

What are the changes being made by and in the revolution, and what developments in art form, theory, and conduct are affecting and reflecting these things? In responding to these questions, it is useful to display quickly the

17

clearest alterations and their causes so that we may soon see the shape and meaning of the whole. Let us then contrast revolutionary beliefs, attitudes, and acts with those they are replacing.

For many centuries one could be fairly clear about what sorts of things were and were not embraceable by the term *art*. True, innumerable philosophical efforts had not yielded a generally accepted reply to the question "What is art?,"[1] but hope of such a reply persisted and it appeared that there really was something to define out there. Belief in the bounded category *art* could therefore persist. Clearly paintings, sculptures, prints, poems, and symphonies were among the sorts of things that one knew he was referring to when he thought of and about art. Such things were, in practice, candidates for honors as art; they were the kinds of given about which art enthusiasts talked and art critics made judgments. Just as clearly, such things as breakfast foods, conversations with friends, business deals, baseball games, dishwashing, trees, and so on were not considered embraceable by the term *art*, though we spoke (loosely, we thought) about "the art of conversation" or "the art of batting a ball." Now, however, there are many intelligent, reasonable people who think *anything* is possible to be considered as art,[2] including the things proscribed above and more. A blurring, or even an erasure of boundaries between art and nonart has occurred.

The Emerging Features

Two sorts of development evidently had to be involved in this blurring of categories: objects had to be executed which, while seeming artlike in some respects, extended into areas usually considered nonart; by thus overlapping, they obscured boundaries and created doubts about where art ended and nonart began. Further, the task of defining art, the marking of its bounds, had to be abandoned, thus

making any assertion about or belief in the existence of bounds to art seem unjustifiable. Indeed, overlapping things were made—for example, found-object sculpture, Environments, and Happenings—and, in fact, philosophers of art eventually did generally reject the problem of defining art as a false and fruitless one.[3] Furthermore, forms that overlap traditional art boundaries are now seen by revolutionists as theoretically privileged, in that they demonstrate the truth that art is no longer a discrete realm; it cannot be limited to framed objects, museums, traditional materials, or, indeed, limited at all.

Moreover, today revolutionists urge that those impulses (I will call them loosely "aesthetic" impulses) that usually found their manifestations in art should not be reserved for art but should be expressed in the world at large, where they are badly needed to make life itself a beautiful thing, a work of art. Indeed, one should choose or develop a beautiful life style and use in it whatever aesthetic behavior is adjunctive to it. Kinds of artistic conduct not useful for yielding this life style are thus to be denigrated. This is a radical view, considering that traditionally it was considered admirable to channel one's energies and shape one's life toward high art production. High Art was regarded almost as a religion, deserving of full devotion, even to the impoverishment of the rest of one's life and environs. But now art, life, experience, environment are to be one, and the one is to be artlike, beautiful. Whereas people involved in the art world were once considered an elite, because of their talent, sensitivity, education, and wealth, today they are derided as snobs, people acting exclusively without justification, since art is in fact indefinable and in fact open without restrictions to all. The elitist art world is seen as so bad and foolish that participation in it is not even sensible, much less a reason for pride.

Such are the major changes of our revolution. Now let us look at the factors that constitute and build them.

Dada Demonstrations

Some of the largest components for these changes come out of Dada,[4] for that movement provides breakdowns of boundaries that foreshadow our revolution and provoke revolutionary thinking to this day. True, art and life boundaries overlapped before Dada (1916)—in Dionysian festivals, medieval pageants, fetes, political demonstrations, everywhere aesthetic concerns were highly prominent and yet merged imperceptibly with religious, erotic, business, political, or play concerns. But it is with Dada that we get the first instances of art—usually seen as a discrete and real category—being deliberately challenged *as a category,* by a purposeful blurring of its border with real life. For example, Marcel Duchamp exhibits (as art?) found objects, things out of everyday life (e.g., a snow shovel, a bottle-drying rack), and so calls into question the line between art and nonart objects. Jean Hans Arp "creates" by dropping pieces of paper onto a larger sheet and pasting them down where they fall by chance,[5] and so calls into question what is and is not art-creating process and method. Others take nightclub acts, a form of theater art, into the audience; the line of demarcation between the art "given" and the "givens" of everyday living thus is questioned as "The Act," and our acts become intermingled and appear undifferentiatable.

Indeed, Dada proffered answers to these questions, some stated explicitly, some discoverable in Dada today only by those who view it through the overlaps of other and later developments. For Dada gave what seems to be an important phenomenological demonstration: it made evident that it is the kind of give-and-take, the mode of object-subject relationship that an object is involved in, that determines the kind of object it is. This becomes most obvious when objects are presented to subjects in several different modes consecutively: thus, a totem pole is a heraldic, clan object when in the Eskimo village, a scientific object when

removed to become the focus of ethnological study in the Museum of Natural History, and an art object when shown aesthetically in the Museum of Modern Art. Without the pole's changing to meet new categorical specifications, or changing physically at all, it becomes a different kind of object in each environment, because how it is given and how it is taken, what it is given and taken *as*—differ. It is not at all mysterious; it is perfectly understandable why the object's appearance would differ in each mode of givenness: a different potential of the object is realized by the different receptive attitudes. The object is different whenever its several potentials are realized. So, to give and take an object as "art object" means to have its aesthetic potential realized. And this Dada demonstrated.

But, as Duchamp later vehemently insisted, Dada's chief emphasis lay not in demonstrating that everyday objects could be sources of aesthetic delectation if taken aesthetically (though that remains the case); Duchamp's "Fountain," a urinal, was not presented to make *that* point. Rather, Dada demonstrated the more important point that the give-and-take for an object can be altered; it is not fixed by the object's membership in a category; for example, a thing usually regarded as being under the category *tool* can be taken as art, and a thing usually regarded as being under the category *art* can be taken as a tool. This challenges the very ideas of categories and categorization, for it means that one cannot say categorically that a shovel *is* a tool, or a statue *is* an art object, but only that they may be taken as this or that, and have potentials for performance under such-and-such categories. Thus, not only were the definitions of particular categories challenged by Dada, but also our sense that fixed, reliable categories for objects *exist*.

To artists particularly, this said that an object need not have been made to some set of art specifications, nor made in the manner in which art is usually made, nor originally presented as art to be *taken* eventually as art, that is, as an aesthetic sort of phenomenon. One has only to establish the

proper context or environment, thus directing people to bring the aesthetic mode of attention to the object, and the object is then an art object. It never necessarily *is* only one thing; being apprehensible aesthetically, it *is* art object when so taken. Hence *anything* can be an art object, for anything can be proffered and looked at for its potential for rewarding aesthetic attention, and no fixed categorical bounds can preclude this possibility.

Overlapping Dada

We know that for many years Dada continued to be practiced but was minimized by most of the art world, considered mainly an interesting historical aberration, a prelude to a real *art* movement, Surrealism. Obviously this is no longer the case. While I will not try to say definitely why our change in attitude came about, several possibilities suggest themselves. Some developments in existentialist philosophy, in sculpture, and in Pop art effected an overlap of some of Dada's results and so, as it were, substantiate or "densify" them by their (partial) coincidence. Whether this overlap was perceived sufficiently to account for our new interest in Dada is a question of concern to the historian; but the potential for being perceived as substantiating factors, and the coinciding results of these factors, are real, and are readily observable.

For example, if we apply some of Karl Jaspers's existentialist thinking to Dada, it becomes apparent that not only in appearance but in function also, anything can be an art object. For such objects often act as symbolic forms; they serve to mean, to signify; and in so doing, notes Jaspers,[6] they often act as a stepping-stone to a new level of awareness. But any object can so act; a thing that we see everyday and hardly notice may suddenly be "seen in a new light," come aglow with meaning—become, that is, symbolic. The difference between art and nonart objects is that the latter *may* act as symbol, but when and if they do, this is happen-

stance; they are not contrived to do so, whereas art objects *are* designed to capture and reward attention, and to be looked to for meaning. However, this does not prevent anyone from moving everyday things into an art mode of give-and-take—the mode wherein serious contemplation is normal—and thus using mundane things to advance our awareness. When they are so moved, mundane things become art, not by changing their properties or fitting art's categorical specifications, but by acting to an end art normally serves in our psychic life. Jaspers's ideas then, though not about Dada, can be, and might have been, applied to Dada and be seen as justification and amplification of it, years after the fact.

From the reflections (perhaps upon Dada's lessons) of John Cage and Robert Rauschenberg, we learn that anything the artist says is art indeed *is* art. This statement, though apparently arrogant, really does not say that the artist is the sole judge of aesthetic excellence, but merely that an artist, at his discretion, can present anything for aesthetic contemplation and that anything may go into the art mode of give-and-take when so proffered, or *should* go if, as is only right, one takes things *as* given. It says that *art* may be entered at will by the artist with anything, for art is not a bounded, fixed category.

Furthermore, why speak only of the *artist* as proffering things for aesthetic regard? Is not anyone, anyone at all, who presents something for aesthetic contemplation acting as an artist? The artist is such, after all, only by virtue of his giving things *for* aesthetic reception; surely anyone so giving is thereby being an artist. Is the person who presents flowers for their beauty, driftwood for its expressive form, a scene framed for viewing by a well placed window *not* an artist in so doing? Evidently one can move into "artisthood" not by seeking training and accreditation, but by acting appropriately. The doors into "artisthood" are open because all can undertake to play the role.

It seems clear that Jasper Johns, Robert Rauschenberg,

and the Pop people add substance to Dada's implicit asser-
tions by reiterating and drawing attention to the unreliabil-
ity of categories through creating works that suspend us
between categories. They make things that hang us up be-
tween the art-taking attitude and that employed in every-
day life—things that seem given to be taken as "art" *and*
given to be taken as "everyday perception" also given to be
taken as *both*. How one is to react is thus made uncertain.
Hence their work confirms and adds (their) substance to
Dada's challenging of categories. For example, Rauschen-
berg includes, as part of a sculpture, a Coca-Cola bottle. We
know how to take such bottles in our daily travels: we are
routinely casual and businesslike; we drink or refuse, re-
turn it to the store or throw it away; we know how to take the
bottle because normally it is given clearly as a routine
perception, just something useful we came upon. We also
know how to take sculpture: we contemplate it, regard it,
ask ourselves, as it were, "How does it feel to be involved in
this psychologically distanced give-and-take?" But when
the Coca-Cola bottle is part of sculpture, we may be con-
fused as to what attitude is called for; we are "hung up"
between taking the bottle as everyday perception and tak-
ing it as object-for-contemplation; we are dangling "in the
gap between art and life" (Rauschenberg). Such experi-
ences reiterate and overlay Dada's contention that our
categorizations are constructed and mutable things, not
fixed reality.

It seems clear that the message of these several develop-
ments all coincide in saying that life and art are not un-
changeable, discrete, or even merely overlapping
categories, but are fabricated containers made to hold and
exclude what we will, and that the walls of these containers
may be demolished and distinctions blurred or left out. The
great meaning of this message for our revolution is evident.

Also, out of Pop art there emerges a breakdown of the
boundaries between high and popular art, and even of
those between high and low social strata. We know that the

attitudes of the various Pop artists differed greatly, but in some cases, whatever their position, their high-art products often seemed identical with the popular forms that were presumed to be merely their subject matter (e.g., Andy Warhol's soup-can facsimiles). The obliteration of the distinction seemed to be intentional with Warhol. High art/low art differentiations become, then, difficult to make, and making them difficult seemed to be a point of Pop.

Apparently something analogous was occurring on a social level, and on a Pop-art basis among others. Obviously great social, political, technological, and cultural developments account for the greatest breakdowns between class boundaries these days, but the breakdowns are revealed and promulgated as clearly in and through Pop phenomena as anywhere. For example, Warhol used the same technique—the popular snapshot and dime-store photo and the commercial silk-screen image—for his portraits of Marilyn Monroe and Mrs. Robert Scull, wealthy art collector. What was good enough for the tragic popular movie queen was good enough also for ladies of high social aspirations. And why not, if the Queen of England found the Beatles worthy of her royal notice and if Bob Dylan's lyrics are good enough for high-art literary reviews? Thus, some high-born and low-born people meet on the grounds of an art that obliterates high-low distinctions in art, and they call the meeting good, endorsed. We may see how this demolition of boundaries lends force to and extends other breakdowns of borders, and how such breakdowns facilitate the merging of art and life today.

The Happening

The particular form that has made the largest single contribution to the revolution is the Happening.

Allen Kaprow, the chief, though not sole developer, of this form, defined its range and its (or his) several categories.[7] The specific subspecies need not interest us

here, but we should note that while Happenings include, at one end of the range, merely informal theater pieces of nontypical dramatic content and shape, as we move along the range they include, more importantly, partially planned, partially improvised events, in which people who would normally be detached observers (audience) become physically involved participants in the events. Most important, Happenings include events in everyday life, which become a Happening only in that someone—the artist-Happener — *sees* the occurrence *as* a Happening—that is, he sees the occurrence as an aesthetic given, or he becomes attentive in an aesthetic mode of awareness in a situation to which he might ordinarily bring only other sorts of attention. By changing one's mode of regard, not his overt behavior, one can change, say, a meeting with a friend from an instance of normal social intercourse into an interplay between personae in a life-drama. One can not only act and be acted upon as usual, but also watch the actors and watch the action unfolding.

This sort of Happening goes further toward blurring and melding the art-taking/life-taking postures than does, say, Pop sculpture or any other art form, for in the latter kind of Happenings, our own bodies, and those of others, and experience itself, become art, that is, they become the given in an aesthetic sort of give-and-take. Then the realm of art and the realm of the everyday object and event are merged, for where would one end and the other begin?

Life or Art

With the possibility of taking aesthetically not only all objects but experience itself, a number of provocative opportunities and questions are presented, and the existence of these as real and now-realizable options constitutes a revolutionary change in my own area of interest. For one thing, although everyday events, quite without alteration by

us, *can* be taken aesthetically, it has become clear that one can also *work* to assure that occurrences in his life will be gratifying when so taken—will be *good* as aesthetic givens. One can work at "life-art," so to speak, by contemplating natural beauty, by expanding the range of his erotic life, or by growing vegetables (to cite a few things currently so labeled). The opportunity to work at life-art seems a legitimate one, and people are availing themselves of it.

More importamt, it would seem that one has the opportunity not only to present himself with occasional experiential events that are aesthetically gratifying, but also to make all experience—the very shape and substance of life itself—fine as an aesthetic given. One can live life *as* art. This might mean—as it has meant to some people —allowing one's behavior to emerge spontaneously from his needs, as opposed to being governed by the boss; engaging in processes determined by one's goals and materials, rather than those of the assembly line (whose fitness and meaning is unknown to the worker); and letting the order of one's days be shaped by nature, rather than by the time schedule of business and industry. This might include making things, if the making and the things made are adjunctive to life as art and fit well within it. There seems to be nothing to preclude this possibility, and people are indeed attempting to realize it.

Even to regard this opportunity as a considerable one is to rise in opposition to previous thinking in the field, to the belief that one should tailor his life to the production of high-art objects, not to a life-style chosen first.

Why a choice and not both? Acquisition of the skills used in high-art production, and their employment therein, requires concentration of time and energies, funneling them toward the narrow end of object-making; the practice of life-as-art requires spreading one's attention and efforts to a broad total endeavor, and spreading some of one's resources to each of many parts. The high arts, then, pull (as it were) life into art's service; other arts (i.e., the life-arts), less

demanding of concentration, allow diffusion and are therein better as adjuncts to life-as-art. And so one must choose between concentration and diffusion, and between the arts involving one or the other disposition of one's attention and energies. And when, as now, the option for diffusion and life-as-art is seriously considered, that in itself poses a challenge and makes a change in the field of art.

Moreover, that option not only exists now, but is being supported by numerous developments within and without my area. I shall continue to note these, but even in passing I may observe that the demise of religious and political ideology and the rise of existentialism and Zen, along with the current concern for self-actualization and realization, make us not much inclined to devote ourselves to far-off Absolutes, such as Truth, Beauty, Mankind, God, and the State, and more inclined to view our days on earth and experience itself as the most important and precious things we have. One is therefore inclined to make them optimal *as* time spent and *as* experience, to make them art like. When, moreover, art ceases to be even a firm (much less an absolute) category, in part because of the developments I have noted, its call upon us to make it a primary choice is greatly weakened. Our counterculture, too, points out the poor quality of our life and proffers new, more artlike life-style possibilities. If these considerations have weight, opting for life-as-art must seem at least reasonable, perhaps more so than choosing to subordinate one's life to the production of art objects. When this appears to be a possibility to people in the art field—one, indeed, realized by some—the field is a changed one.

The Theoretical Pressures

The new options and their sometime realization change our world by saying You may, you can, and why not extend aesthetic regard beyond the high arts and into and over all of life? But we may now also see that there are ideas cur-

rently circulating that do not merely leave the doors open to extended aesthetic practices, but close the door on traditional ones, casting so much doubt on the legitimacy and wisdom of practice in the high arts as to leave no place for our aesthetic impulses and interests to find expression *except* in life at large. It seems natural then, to find people asking, "Why isn't everyone an artist?" as if universal "artisthood" were not only permissible and possible, but obligatory. If the ideas now circulating preclude high-art practice, and if practicing "life" is inevitable, why, indeed, would not everyone practice life beautifully, like an artist-at-living? Some people, especially our youth, do talk this way, and perhaps the ideas I shall present below account in part for this sense of obligation.

Let us consider first those theoretical developments which seem to discredit the mission and meaning of high art and eliminate its right to be considered a discrete and special thing. For a functionless, nothing-special sort of art—an art just like everything else, in theory as well as in the practices noted—is mergeable and indeed identical with life at large. Continuing to create forms that only pretend to loftiness or special meaning would not be permissible, and practice in a new, merged, unpretentious realm would seem obligatory, required by the fact that art and life are indistinguishable—are, in fact, one.

Denying Vanguardism

It has long been believed by many people that art occupies a special and high place on our scale of things valued because if fulfills a special mission in life. Until recently, this sense that art related to some grand human need often found its focus in beliefs about the vanguard role of art. The purposes and functions of avant-garde art are, it was said, multifold. Sometimes this art served to make one see nature and people in a novel way. Sometimes it served to needle the bourgeoisie, to shock and disrupt smug, static

thinking. Sometimes its purpose was to increase the sorts of exciting experiences available through art by expanding art itself. But, to put it most comprehensively and grandly, it was thought that avant-garde art pioneered new paths for human awareness, helped persons and mankind transcend their current limits and achieve higher levels of consciousness.[8] This view apparently was part of a larger vision of mankind as a self-surpassing, spiritually progressing species. Understandably, as long as art labors towards such purposes, it is considered a lofty and worthwhile endeavor.

But now there have arisen both conditions and arguments that work against a belief in vanguardism, and though it is theory that concerns us now, the conditions that reveal and generate theoretical concern should be noted also. These days, "front" and "rear" shift regularly in the art world, often, it seems, through crass manipulation and to no apparent avail. The Promethean art-hero frontiersman seems to be scoring breakthroughs every two years, that is, as often as his one-man shows are scheduled, and so he begins to look like a mundane, cynical commuter between the fireplace and Madison Avenue. There is also evident in the art world so much faddishness and phoniness that allegations of spiritual advances seem suspect.

There is also the problem posed by the dearth of really new things in high art, newness being a necessity if the idea of a vanguard is to be credible. Recent high art developments seem more like ramifications of forms and ideas already extant than radically new explorations, hence the image of the pioneer artist pushing ahead the limit of human consciousness is hard to hold.

As for theory, we get from Jack Burnham the argument that the avant-garde indeed has ceased to function, and for good reason: it completed its tasks. These involved the exploration of artistic forms analogous to the five possible

types of sentence structure. When these have been explored, nothing is left to art but to be handsome decoration.[9] And, one may say, this is why there is a dearth of vanguard art; Burnham's argument is both a denial of the vanguard and an explanation of its demise.

Some of the bases of vanguardism are being challenged today by often noted changes in world view emerging out of our counterculture and our technological development and currently creeping into the public consciousness. For example, vanguardism depends in part upon our seeing time in a linear fashion—time must march like an army column or flow like a stream, otherwise there are no forward motion and no advanced front in which an avant-garde could be a leading participant. But the counterculturists influenced by Zen, by Hippiedom, and by certain effects of the mass media have indeed become the Now Generation, which is to say that they see time oceanically, as an enveloping, cresting, and subsiding everpresence. Yes, persons can advance by expanding their awareness, and societies can be improved, but this oceanic view precludes the upward march of mankind along a time line, a march that was part of the vanguardist-progressionist-evolutionist viewpoint. For this reason, the vanguardist attitude and mission totter and fall.

We must remember that avant-garde art has long been considered as the only art that matters: surely noninnovative or academic art is considered of negligible importance. So when the avant-garde dies, art dies. Thus, even in consideration of no other developments (and there *are* others), we may see that it is now not merely permissible to bring our aesthetic impulses and abilities to life at large, it is apparently obligatory, because there is no place else where they can be expressed legitimately. If given the choice between participation in a finished, empty, expired enterprise and the useful, vital employment of our talents and energies in

everyday life, one is obliged to choose the latter.

The Weitz-Peckham Viewpoint

Aside from vanguardism, now the very concept *art* is called into question. For example, Morris Weitz and Morse Peckham[10] have described art as a concept so open and arbitrarily defined as to include apparently anything at all and to point to no special thing. If they are right, what then would anyone mean by *art*? What would be valuable or even respectable about it? And how could one practice this—this nothing-in-particular?

Weitz observes that down through the ages men have sought to identify art's least common denominator, some necessary and sufficient art property or function, and they failed. And he indicates that they failed and will probably continue to do so because it may well be that there is no quality or function common to all art. He suggests that we do not in fact call an object "art" because it fits an acceptable definition. Rather, what we call "art" today is known as that because it shares some traits with objects we called art yesterday and only this overlap is necessary to identify the new things as belonging in the art category. There is no common element in, say, the Parthenon, a Rembrandt, a Sumi-e ink drawing, a Braque collage; there is only the family resemblance of each form's looking somewhat like a form before it that was called art, but also somewhat differing from it, and hence extending different properties into the art-world, properties that then can be shared but also deviated from by still other forms. Thus the youngest things in the art family have nothing in common with the earliest ancestors and the newest things are art, not through possession of the property or function that defines the category, but through human decisions as to what are the legitimate children—that is, acceptable overlaps and extensions of the family. Weitz asks us to give up defining as a useless effort, and to investigate what goes into our art-related decisions.

For example, why is it that our use of the term *art* occurs precisely when and as it does down through the years, and what language developments occur, what social dynamics prevail to account for the specific application of the word for just those objects where it is used?

Morse Peckham's argument, in *Man's Rage for Chaos,* contains, among other things, a response to the questions raised by Weitz. Peckham urges that whatever people at the highest cultural level say is art is indeed taken as art. This elite approves or disapproves of certain overlaps, certain children of the then-known art family, and thereby also extends art in certain directions, extensions stemming from precisely the ways in which the children differ from the parents. Moreover, there is in the actual practice no apparent limit to, or ingredient required in, the things that these people's decisions may embrace, because in fact the conformity of an object to a theoretical definition of art is not considered, nor is there an art element unwittingly responded to by the judging elite. Anything can become a member of the (art) club so long as the art-shaping elite does not blackball it. What is or is not art is then simply a group decision, and it is apparently arbitrary. The judgments of the elite can be investigated, perhaps accounted for as historical-sociological phenomena, but only the *meaning in usage* of *art* can be determined; linguists, sociologists, historians, and so on can perhaps explain the word's employment and application in various times and cases, but definition of art is impossible. Much as we know that there is no property of *royalty* in Great Britain's royal family and that, had different armies won battles and different political and economic events taken place, another family would today be called *royal,* we also must know that there is no property of *art* and had different parties won the aesthetic battles, other things would be called *art* today. *Art,* then, is only a fabrication. Our realization of this should proscribe practice in *art,* a made-up field of endeavor.

The Marcusean Influence

Some other reasons for finding the abandonment of high art obligatory come from the highly influential writings of Herbert Marcuse.

Marcuse argues [11] that in any highly industrialized, advanced society, every person and every vocation help maintain the System; we are so integrated and interrelated that we each and all must take credit and blame for the persistence of the System and for its yield. And now, says the (art) revolutionist, when our System's qualities and outputs are severely challenged, even to play the apparently harmless role of artist is wrong. For the artist is a mere entertainer of the troops, or worse still, of the generals; or he helps accommodate people to a bad world. And the System can contain and digest anything the artist does. Even rebellious and outrageous art acts feed the System, and the artist cannot escape damnation. Especially evil is expensive, elitist, high art, for people starve and the nation makes war and high artists make playthings for the rich, involving expenditures better used to serve humanity. At least other more democratic and widespread arts should prevail.

Moreover, Marcuse's revisions of Freudian belief[12] also may be seen as prompting the obligation to leave high art for broader endeavors. To put it crudely, Freud argued that, to live in society, the individual has to bear the burden of work, and he has to repress or sublimate his libidinal impulses. The Reality principle, not the Pleasure principle, must prevail in the adult's life, And art is one outcome of this repression and sublimation.[13] Art is generated and shaped by our bottled-up or transformed energies and wishes, and art is so shaped because reality cannot be. Marcuse, however, asserts that Freud was wrong when he took the toil and repressiveness of the status quo in his time to be immutable Reality, for in fact only Performance, reality to date, is laborious and repressive and this current reality is not inevitable or fixed. Given the possibilities of modern technology, radical new social structures, new sex-

ual mores, and the like, we need not feel forever bound to work, bound to repression, and hence bound to find beauty and freedom only in private, self-constructed worlds, apart from the real world. We now can and should change our lives and our world, to make them more just and beautiful.

Indeed, we should make life more artlike; Marcuse makes art the exemplar of what life should be. The fine amalgam in art of feeling and intellect, the happy relationship of subject to object, of thought and action, Marcuse believes should characterize behavior and living generally.[14] Art demonstrates the possibility of such a blend in one (its own) sphere of existence, and if repression and exploitation end, a lifelike art will be possible. Clearly, today our environment, communities, and personal lives could benefit from an increase of aesthetic attention, and if these realms are not doomed to be bad by a sad immutable reality, we should try to make them better. Painting and sculpting, then, are only easy recourses to satisfactions on a small personal scale when a broadly satisfying life and world should be made; these high arts are thus deplorable.

High Art as Anachronistic in Theory

There was a time when art meant painting and sculpture and the acquisition of the techniques necessary to realize these ends required a set of "how-tos": how to mix colors, how to apply pigment to a surface, how to build an armature, etc. In the last three years, at least, it is clear that the techniques of art have been revised to become not so much studies in methodology as of research into what constitutes the elemental features of any particular situation. In my view the methodologies necessary to the artist are now art history and philosophy—the one to know where to begin, the other to know what to do. The methodologies then pose a set of questions, which in a certain sense, have never been raised before, at least not in the sense that the questions themselves constituted both answer and art.

—Robert Pincus-Witten,
Artforum 10 no. 4
(Dec. 1971), p. 29.

...The important thing is that the kineticist is trying to make himself relevant in a world which is continually being recreated. He has refused to become an anachronism painting or making vapid gestures with larger and larger surfaces.

—Jack Burnham,
Beyond Modern Sculpture (New York: Braziller, 1968),
p. 284.

To add further to our sense of obligation to abandon high art and extend our aesthetic impulses to all of life, we are told that such high arts as painting and sculpture are anachronistic, hence proscribable. We have noted one such allegation before in Jack Burnham's argument[15] that the avant-garde completed its job by exploring the art forms conforming to the five basic semiotic forms. But it is also evident that the high arts are incongruent with the world around us today. They involve handcraft, archaic materials, individual effort, and are not reflective of or continuous with our electronic, analytic, automated, information-centered, jet-travel age. Perhaps the arts of concept-giving, of television, of environment-shaping can be practiced in ways appropriate to our times, but not painting and sculpture. They are just not contemporary. And if their tasks are finished also, surely serious people ought to do real work elsewhere.

Hence, given the practical precedents for aesthetic extended practices and the good opportunities in them, and, on the other hand, given now the doubts one must entertain about high art, one must find the former the proper choice.

Bad Conditions in the Art World

The belief that we are obliged to leave the high arts for broader aesthetic practices is buttressed by the allegedly deplorable conditions in the world of high art; all theory aside, that world, it is said, is no place for good, intelligent people. Understandably, the arguments mentioned above

do help one find the art world deplorable and hence a world to be abandoned. While art was itself respectable, the bad practices surrounding it might be excused; art was the redeeming good feature of the poor situation. But with art undermined in theory, nothing excuses the bad art world.

Let me be a bit more specific and see what it is the revolutionist deplores and what he says and does about these things.

Elitism

We know that high art is usually regarded as the exclusive province of the gifted, specifically trained people who make the art objects and of the rich, sensitive, well-educated people who appreciate, evaluate, buy, and sell the objects.

Moreover, though money is usually involved in art dealings, the art realm and its participants are generally considered idealistic, of a higher order than others, therefore involvement with art redounded to the credit of the participant. We see, then, why an elite is associated with art, and why the elite could purport to be one of virtue and high purpose as well as of money and talent.

Such an elite is, then, one especially likely to think itself superior; it is likely, that is, to practice elitism, a self-conscious, smug, exclusive higher-than-thou posture. Experience in the art world reveals that this likelihood is often indeed a reality. And while it may be good to *be* superior, it is certainly bad to *act* superior—to be an elitist.

Moreover, the practice of elitism seems worse now, as all semblance of justification goes down to defeat under the assaults noted above. We have seen that the revolutionist can now attack the idea that art is something attributable and limitable to a few gifted and well-educated people by claiming that anything anyone makes or does can be regarded as art, and that no standard can be cited and used to exclude works or people from art. So if all things can be taken aesthetically, and one becomes an artist by proffering

things—any things—then everyone can be and often is an artist, and the title does not matter any longer. It certainly does not grant privilege; the art giver-and-taker is not especially fine or virtuous, is not in fact part of a superior group, and the pretense that he is is therefore damnable.

Even those people still working, however humbly, in fields not open to the untrained (e.g., marble carving, easel painting) are damnable as elitists, for they are, without justification, withdrawing behind the walls of exclusive estates where other cannot follow.

The revolutionist also sees as elitist the making of kinds of art that most people cannot understand and enjoy. There is indeed much that is obscure and esoteric about high art; it is as if the artist were encoding his messages (if any) so that only a privileged few—the holders of the code-book—may understand them. Surely art ought to be made accessible to everyone, and because high art is not, it avoids the very thing it should seek—social usefulness. Again, this is execrable elitism.

Art as Commodity

As for the well-known practice of treating art as a profitable commodity, this betrays whatever the artist intended for his work; clearly one does not get what is given *as* it is given if one takes art objects in a businesslike mode of attention, the mode we bring to commodities. Moreover, such perverse taking adds hypocrisy to the other sins of the rich elitist. It is bad enough to find people still claiming to be elite without theoretic justification, but still worse to find them adopting an elitist posture while crassly using art for profitmaking. But the fault lies not only with individuals but also with art itself. High art objects have a great potential for betokening wealth and for investment growth, hence they seem doomed to elitist usage and doomed to play a commoditylike role. Clearly this speaks ill of art and its world.

Art as Secular Religion

Another art-world practice is now seen as being as futile and pathetic as it is deplorable. The aesthetic life has become for many people the surrogate of the religious life, and art, even for those not completely devoted, becomes holy—that which should be worshiped. The explanations for this phenomenon are well known: for the many to whom God, man, and ideology are dead, there is a kind of spiritual emptiness; for them there are no ultimates toward which their aspirations can wing, no shrines to kneel at, no glow of affect from some immanent goodness, no saints to revere, no Scripture to study, debate, and obey. Art is being used to fill the void: aesthetic progress, or beauty, or expression becomes the ultimate, the distant star toward which one reaches; masterpieces become shrines, places numinous and sacred with the touch of the Great Ones; artists, especially those martyred and basically simple, become the new saints, and Scripture appears regularly, instructing us on how to get into heaven and telling us who is appearing where these days. Also, the aesthetic-religious life is not too demanding (except for the fanatics); services are held not only on Sundays but all week, the galleries are comfortable (hard on one's feet but not on one's knees), and there is even an equivalent of Sunday School for the children. Instead of hearing of heaven and hell to come, one is surrounded by intriguing and often pleasant things right now.

And the artist can work at tasks he finds spiritually meaningful; he can, he thinks, make a sacred core to his life. One can congregate with others of the Saved and discuss the latest Manifestations and feel pretty good about being among the few who have found the Way.

The trouble is, the revolutionists assert, art is not as such credible, for one thing, and it does not really work well as a religion in any case. It may be the best we can find, but if so we are sad creatures, maintaining ludicrous postures. For

however much we worship beauty or expression, and how-
ever much we make them real on earth, this does not make
divine justice rule the universe (the innocent still die acci-
dentally), and this does not make a divine plan govern our
destinies (no ultimate meaning of all our doings appears).
In fact, our saints, priests, and theologians are just working
people, moved by all sorts of impulses, needs, and interests,
bad and good, people extraordinary only in their ability to
do some few things exceedingly well. To ask art to bear
burdens that one's religion once carried is to be pretentious
on art's behalf, and futile. Yet art people are pretentious in
just this way, and they and the futile world they create are
therein damnable.

Art World as Entertainment World

For one thing, we are still living with the consequences of that
influence [that of Pop Art] which transformed a large part of the
art scene into a branch of show business, with all of its attendant
ballyhoo and baloney and ersatz art.

—Hilton Kramer, "And Now—Pop Art: Phase II,"
The New York Times, January 16, 1972.

The art world also has a potential for acting as a realm of
entertainment, and because this potential is being realized
to our detriment, the art world and its contents seem de-
plorable to the revolutionist. Certainly we have our
"shows," our critics with reviews in mass (and more re-
stricted) media, our opening nights with admiring fans,
rich patrons, and considerable hubbub and glamour, and
of course our Stars and Big Producers. For some, art is
clearly a world of sparkle, excitement, and dramatic events.
But the concomitants of this tinsel-town, theaterlike world
seem to the revolutionist execrable. Perhaps we may wave
aside the allegations of Hollywoodlike artistic prostitution;
we may shed no tears over the young artist returning from
New York, hopes dashed, to rot again in East Podunk; we

may ignore the pain of the thousands who must either be "in," a Somebody, or "out," a Nobody. But we cannot pass over the fact that the art world is generally a bad employer, one made so partly by its entertainment aspect. That is, the (our) entertainment world needs stars, as focuses of attention, as creators of glamor and excitement and profits, and as model-giving images for people to emulate. And for these purposes, *few* people are needed. So when the art world becomes the entertainment world, it becomes a bad labor market, and what rankles is that art becomes a bad employer by choice, not necessity. The artist knows he would have only himself to blame for his unemployment if he went into an enterprise that is inescapably overstaffed and has no jobs available because it *must* employ few people, but he also knows that the question determining the size of the art enterprise might have been, "How much art does the nation need?" Art people asked not this question but instead chose to ask, "How many Stars are needed?", and thus opted for artists' unemployment. Hence the entertainment aspect of our world—and it is large—is damnable.

This aspect must stand condemned also on the grounds that it encourages a perversion of art, or at least of what artists usually avowed were art's high purposes. The taking of art as entertainment tends to make artists and others concern themselves with an art work's potential for providing excitement, star quality, and theaterlike gossip and debate, and this is to place foremost what should be of peripheral interest. Hence this practice, and the world evidently much involved with it, cannot be respected.

The Overvaluation of Art

The revolutionist notes that millions of dollars are currently being spent on old masterpieces and tens of thousands on new ones; also, people's lives and our communities' resources are being spent on art, and fulfillment of our other needs is deferred because of such spending.

Now, with art objects no longer seen as the sites of psychic breakthroughs or sacred pilgrimages, there is no justification for such practices. We have, then, persisting overvaluation: high prices paid without fair recompense received. Hence the art world is an inflated, pretentious, fraudulent place.

And some nonmonetary expressions of overvaluation —for example, preciosity—seem as deplorable to the revolutionist as overpayment for art objects. Consider the practice of artists working on "the problems of [their] art," meaning usually that they are researching, exploring, and refining small areas of artistic practice and aesthetic interest. Now, why do so? Surely preciosity is involved. True, even practical, hard-nosed producers explore *their* problems, but presumably such people do so only to the end of getting them out of the way and getting the product made. If members of, say, the shoe industry do focus on a shoemaking problem itself, losing sight of the larger goal, this does not smell of preciosity because the problem is clearly subsumed under and related to a larger, socially useful, enterprise. But painters, by contrast, are apparently not interested in getting their problems out of the way so as to get on with making socially useful paintings; they discern only problems that yield paintings when one works at the problems, paintings that may be useful or good only for solving the problem that was discerned so that it could be solved. We thus have a self-contained, self-justifying, self-rewarding enterprise, a world apparently delighted with and highly valuing its own little contrivances. But there is no reason for sensible people to care about such contrived problems or their solutions, or the world that thrives on such useless preciosity.

The revolutionist concludes that, since the world of high art is bad in so many ways, we ought not to practice high-art forms, forms that lend themselves to such abuses, and we ought not to participate in the high-art world. That world was made by and for the art, the art is made in and for that

world, and both should be abandoned for better work and a better world elsewhere. The door is open to make all of life artlike; the door to high art is locked by the above-mentioned considerations. It is clear, then, where our aesthetic interests and impulses should go.

Forms and Ideas in Concurrence

It is now perhaps evident that the several developments cited do indeed have areas of coincidence and concurrence (i.e., agreement)—of overlaps—and that therein they lend each other substance. These areas of overlap become, in effect, changed conditions in the area of our interest; their reality is new reality.

Perhaps I can further illustrate the usefulness of seeing current art developments in the way proposed here, and further amplify my rendition of the revolution, by noting a few more items and ideas residing in part or whole in these areas of overlap.

For example, earthworks are given *as* many things (e.g., land sculpture, ecological statement, conceptual art), presumably for many reasons, but they are given also as non-marketable, anti-museum, anti-capitalist items, accessible to all people.[16] Earthworks in some measure occupy ground substantiated by the revolution, or rather are among the things constituting this ground made by over-lapping developments. We find many onetime high artists making anonymous footprints on vacant lots, or growing vegetables, or leaving flowers for neighbors, to thus make symbolic or beneficial gestures without egotism and pre-ciosity. We get the Art Workers Coalition who do likewise in their very name, making workers out of former Olympians. We also get MUSEUM (in New York), an umbrella for several co-ops, workshops, classes, and so forth disallowing one-man shows as "ego-trips"; and groups within MUSEUM encouraging their members to exhibit anony-mously so as to reduce egotism. And we get process art,

44 TOWARD THE TRANSFORMATION OF ART

wherein nature's and artist's processes shape, and are made conspicuous in, the works, thus to meld nature, life, and art—for example, Tom Halsall's bread piece (where fungi color, shape, and destroy ranks of bread slices).[17] And we get some process art that yields only experience, thus to join in the self-expansion movement along with sensitivity training, drug and religious movements, and new therapies —for example, Philip Simpkin's Black Bag Experience, a group-grope in a room-sized, pitch-dark, black-plastic sack.[18] That such things overlap the aforementioned ideas and attitudes and add substance to them is evident; they also make more evident precisely what are the ideas and attitudes constituting the changed aspects of our world of interest.

We also get Conceptual Art, explorations by means of forms and/or statements about art into what art is and is not, indeed into the very idea *of* art. This movement, like Process Art, which it overlaps, asserts quite explicitly that events, ideas, the concepts in our minds (or even those not yet there) can be considered art, or rather that *art* can mean what those who reflect upon the term, including conceptual artists, determine for it. Conceptual Art is art about art's meaning: meta-art. And part of the movement's intent is a rejection of objects, to avoid making the work into salable commodities and to make it instead professional consideration of the meanings in and the meaning of the field. In this at least, Conceptual Art concurs and coincides with the views of the other artists and theorists cited.[19]

To sum up, let us see what one would believe and do if he lived in these areas of overlap and was spokesman for them and nothing else—if he was that fictitious character, the revolutionist. This person (or personification) opposes practice in the high arts, for the reasons given, and he abstains from devoting his life to such practice. The revolutionist apparently feels impelled to perform acts, with or without physical accoutrements and products, of value to himself and others, acts which, for example, alter a

person's perceptions, expand his mind, change his be-
havior or environment. He thus often wants to be, in the
largest sense, educative.

Or, as just noted, he may wish, more modestly, to make
experiential life a more joyous, abundant thing. The shap-
ing of the good or beautiful life is his primary concern,
even if to the detriment of the high art to which he gives no
allegiance.

It is to the end of enhancing life that the revolutionist
favors participatory and process forms, forms of activity
that involve people in more than passive contemplation.
For it is through active physical involvement that people are
changed. Of course, being anti-elitist and democratic, he
thinks that forms that are restrictive, such as those requir-
ing money or special talents, are not so good as those acces-
sible to all.

Although he may or may not have read Marcuse, the
revolutionist takes art as a metaphor for and adjunct to the
good life, just as many a counterculturist does. We have
noted the manifestations of the aesthetic interest in coun-
tercultural living experiments and life styles.

The revolutionist often exhibits and advocates a high
degree of social awareness, evidenced sometimes in mere
self-protection through aestheticism but also expressed
sometimes in his performing civic-minded, aesthetic
acts—painting city walls, teaching poor kids, doing street
theater, and the like. Indeed, whereas the high artist is
interested in producing goods, the revolutionist apparently
is interested in rendering services, to himself and others.

In speaking of the revolution, then, we refer to no mere
addition to our bag of options, no little rebellion, no student
prank, no mere stylistic turnover. The revolution has ances-
tors and roots, it has ideas, it has people, it has enduring
interests and goals, and it has some effective (though chang-
ing) means of expression and realization in the world. But
of course this does not mean that it is entirely good, right,
and adequate. Indeed a response follows which, I believe,

finds and utilizes good things in the revolution but also defeats, reforms, and adds new dimensions now lacking in the developments cited, and moves on to its own destination.

2
Response to Revolution

Relinquishing Art, Maintaining the Arts

We have seen above a construction of the revolutionary viewpoint; now let us consider a response to it. The thrust of this first and major part of the response is that, although the aforementioned developments seem to close the door to practice in high art and give access exclusively to aesthetic activities that extend into and permeate life at large, the practice of painting, sculpture, and other high art forms in a radically different theoretical framework and art world remains right, though right also is the practice of the extended art modes. They are both right, because both sorts of practices are of potential service to people. This is to say that forms are to be credited or discredited, not by their being or not being *art*, but rather by their beneficence or the lack thereof. Thus I accept a revolutionist view: herein the arts will be considered a variegated service profession, instead of being considered a definable honorific category or realm. But this consideration applies to high art forms as well as others. As long as persons can be elevated, delighted, stimulated, fulfilled or otherwise served by paintings and

sculpture as well as earthworks, encounters, and the like, all these objects and phenomena will remain good. And good they remain even if the word *art* cannot embrace them —and disappears.

I will urge, also, that not only many arts, but many art-life relationships can coexist. There should and will be developed, then, a basis for seeing the legitimacy, usefulness, complementarity, and roles in the world of these coexisting forms and relationships.

Let me begin building this viewpoint by noting what in the arguments of Weitz and Peckham should be conceded and what the concessions mean for us.

We must, I think, admit the strength of most of these gentlemen's contentions; I see no useful way of disputing them. Let us, then, concede that no lowest common denominator of art has been found and that such never will be found—because there is none. What we call art today is only that which overlapped yesterday's art, and so on back into history. And the decisions on this overlapping, and hence the inclusions under the heading *art,* were made by mere social elites, and not through their perception of or response to any art quality. One cannot, then, believe he is ever making or seeing something he can embrace within the concept *art.*

Assuming that these concessions are necessary and right, is there any possibility of believing that acclaimed works of painting and sculpture are something special and not anything some whimsical people took a fancy to? And is it possibly untrue that anything-at-all may be honored as aesthetically good? Do our concessions leave us any grounds for respecting painting and sculpture?

It seems quite possible to believe that the term *art* was and is used to include a great many disparate things that have no one quality or function to which the term might point, and to believe also that these things are nonetheless good and admirable. Nothing that Weitz and Peckham allege or that we know precludes the possibility that paintings and sculp-

tures are good, not in that they are art, but in that they are responses to and fulfillers of diverse personal and societal needs and interests—that is, good for us. And if so, they would be worthy of respect as beneficent, not as art.

It is quite possible to make our concessions to Peckham without precluding the possibility that objects called *art* by judging elites were indeed adequate need- and interest-fulfilling things and *therefore* something special and not anything-at-all. For to say that elite people did not discern or respond to some real *art* quality or capability in the works they called *art* does not mean that they did not discern or respond to some various things good and beneficial for them in the works—properties and capabilities right and sufficient for meeting the needs and interests of the persons involved. Because they are very variegated, the works might not be art—not if an art category requires a common element in all its subsumes under it—but they could still be works of capabilities effective for and sufficient to render service to people, and hence not anything-at-all.

Now, it would be foolish to think that such a sufficiency would amount to much and would be suggestive of paintings' and sculptures' worthiness if one believes that people's needs and interests are ephemeral, insubstantial, insignificant things, mere whims and caprices; "nothing much" and "anything-at-all" could conceivably be sufficient and right for people for whom "anything goes." But I find no reason to think of people's needs and interests this way. Certainly I am not moved to this view by the fact that no set of needs and interests is universal or because a particular set may be fulfilled by more than one sort of need-related thing. Considering people generally, if one tries, say, to provide education or diet for different populations, he knows that a great range of wants, tastes, and aspirations will be operative within and among each of his several clienteles, and that what is good for one group, given their culture, environment, and inherited characteristics, may not be good for another, but this does not tell one that

individual and group metabolic needs are insignificant, or that a particular goup's learning wants are ephemeral and undemanding, and that he can therefore feed everybody anything-at-all or teach everybody any old way. If one were an itinerant educator, the sum of his educative efforts for all his populations would probably be a varied lot of things, but each effort would have to be within the range of rightness for its particular situation. One concludes that persons and groups present realities as subjects—real needs, real interests—that may be fulfilled within a range of acceptable ways, and *must* indeed be fulfilled, if at all, by things operative within the acceptable range and sufficiently efficacious to serve the needful subjects.

I have no reason to think that subjects' demands in my area of interest are less substantial, significant, and uncapricious than those in other areas. There is no reason to believe that in regard to painting and sculpture people generally were not demanding what was right and sufficient for them in their particular situations and getting what they needed. And although the total of such situations produced a batch of things too varied to be called by the one title *art,* each such thing could be considered good insofar as it was beneficial. And if so, the things would then be special, in that a capacity and sufficiency for beneficence for a particular group of people are not the properties of any and everything.

It may be objected that we indeed have reason to suspect that mere capriciousness governs art judgments when we look at the current art world. If all the things Allen Kaprow mentions (see beginning of Preface above) are accepted as art, then apparently art is not matching up with significant interests and needs (and thereby being special and laudable) but is merely within the limitless, unfounded range of caprice, thereby being anything-at-all. It may be said that our current practices cast doubt over the past, tending to discredit all allegations of respectable match-ups heretofore.

But in fact, our current elite's demands and interests are

highly stringent ones and are not at all capricious. Our judging groups are, for example, currently insisting upon explorations of *new ideas*. This instantly rejects sensuous art and ideas once given—and that places a most restrictive demand upon art. We should not be fooled by the fact that almost any sort of *thing,* a thing of whatever objective properties, may be used to reveal the new ideas, and that it may be then said literally, "any *thing* goes"; but none but new ideas "go," however various are the things that illustrate them.

Currently, as we have seen, the idea of amalgamating all of life into art is one that much concerns our sophisticated elites, which prompts artists to reach far for all sorts of things to incorporate into art—indeed almost any *thing* that was not art before will do to extend or stretch the category *art.* But the elite's need for, and interest in this *idea* places strict requirements upon art, however broad the range of *things* that may serve this interest (paintings, for one thing, are useless to this end). So contemporary practice does not preclude the possibility of the real need/real service match-up suggested here. Indeed, nothing does; this possibility remains open.

Summing up thus far, we see that it is quite possible that painting and sculpture, insofar as they may serve to fulfill real needs and interests, could exhibit a good and special fitness; a capability for such service would be a potential inhering in the objects, real as such, and one making them valuable. And such a potential for beneficence and such value would remain, whether or not the title *art* can be used to subsume all the potentials of the objects and all the related services. Given this possibility, works in the arts would be good because good for people, not good because they are art.

Moreover, there is much evidence to suggest that needs and interests not only possibly, but do indeed, generate the things heretofore called art, and that these things are reflective of and responsive to these needs and interests. There is of course much personal testimony to this need/art

relationship. You and I and others experience urges, drives, and impelling interests that take us to the arts, and they are in some measure satisfied there. And though our testimony to this effect cannot be taken at face value—we are not objective and reliable on this sort of thing—our experience cannot be entirely discounted. Moreover, there are more objective witnesses to back us up, if we take their testimony properly.

If we examine much of the psychological and philosophical writings on art's causes and functions, we might read the studies as merely answers to the question, "What is art's one essential property or function?" Indeed, the writings are often submitted as such answers, and our own tendency to think reductively fosters this sort of reading. But we might better look to these studies cumulatively for some evidence and reasons for believing that art serves a number of human needs, no one of which is essential to art but all of which are sometimes present in the arts and important to people.[1] In sum, when not read as definitions, that is what these studies say.

We should be inclined to take them in sum and give them the cumulative reading to the point suggested by the art's historical persistence and what the studies make of it. They speak of art generation because of personal and societal needs of great variety, and thus account for the persisting art phenomena—which cry out for *some* explanation. That is, only by regarding art as need-related and the studies as revealing of the needs and what activities respond to them, do we make sense of persisting historical and current goings-on. The writers note, as we all may, that the cavemen made their wall paintings, and children of almost all cultures draw lines in sand and mark up walls with forms, and sophisticated men doodle, or are intrigued by strange stones and carve them, and people everywhere cavort in what we call dance, and so on. The studies mentioned show plausible relationships between each of such activities and human needs, and a great diversity in and among them all.

True, in most societies artlike activities occur in evidently culture-shaped manifestations, and so one might suspect that the participants do their artlike things only to *be* participants in a social form, but when even the untutored do these things, and when others do them covertly, that is, without community approval, and when the culture demands artlike services for evidently good reasons (e.g., to facilitate religious rites, memorialize heroes, incarnate its values) when they are not volunteered, it seems more likely that real personal and societal needs generate the image-making, symbolizing, form-generating activities given shape by the culture. The variety now evident may make us today withdraw the singular title *art,* but it should not make us doubt that needs and interests exist and generate the things once covered by that word. So, in all, we are moved to find the arts need- and interested-related, serviceable, and hence not discredited by the concessions made above.

However, the concessions made do challenge certain common attitudes. For while we may still pursue our interests and serve people by revealing feelings, creating beauty, disrupting staid viewpoints, stirring the imagination, and symbolically incarnating personal and social values, we can no longer engage in Service to Art, and work at Advancing Art or Solving Art's Problems. Art must be seen now as a construction put upon perhaps disparate acts, objects, phenomena, and it would be misplacing concreteness to make of this construction a solid entity to be served. We will have to cease to misconstruct, and cease to adulate our own misconstruction. The possibility of service to people will be the new ground for our respect for the arts; the old one will not do. Again, the arts may remain because beneficent, even while *art* disappears.

Anything Goes—If It Goes

The foregoing discussion speaks theoretically to the threatening question of whether "anything goes" in the

arts. We see now that in theory not just anything goes because "anything" is not identical with "things right and sufficient to be responsive to the actual needs and interests of persons and communities," which is what the arts are. But we can also indicate the requirement of rightness and sufficiency from a practical standpoint.

As was contended earlier, anything can be submitted for aesthetic contemplation, and when so given and taken it is an aesthetic sort of given. And the person proffering this thing—be he farmer, salesman, or sculptor—is, in this giving act, indeed acting as the artist does. However, although anything may be given by anyone for aesthetic regard, not everything proves rewarding when so taken. Sometimes everyday objects have great potential for rewarding aesthetic reception, but often things not expressly well contrived or well selected for such reception do not; the scenery we pass through only now and then can be given as "a beautiful scene"; the conversation of our neighbors can only occasionally be selected as something to regard aesthetically. There are apparently experiential tests as to what succeeds in the aesthetic give-and-take, and while anything—talk, paintings, housework, a two-week vacation—can legitimately take the tests, many things will, indeed do, fail. We are bored and unsatisfied by them. And those things that succeed are thereby exhibiting a high potential for rewarding aesthetic regard. Though no specific set of objective *art* properties is required invariably to constitute this potential, it is, however constituted, required. To say that a thing must meet this requirement is not to say that anything at all will do.

And not "any*one* goes," either. The selection of things for aesthetic giving evidently requires at least adequate judgment on someone's part of what constitutes a sufficient aesthetic potential; one can be guilty of proffering a dull painting or an unrewarding love affair. No longer are talent in drawing or credentials from art schools imperatives for successful aesthetic giving, but judgmental abilities,

gained somehow, are. And so, while anyone can get into the role of artist, not everyone can play it well. When a revolutionist asks, "Why isn't everyone an artist?" he is asking a question akin to "Why isn't everyone a cook, or a lover?" That is, there may or may not be adequate precluding reasons in each case; everyone *may*; not everyone *can*.

The Arts and Time

Burying Vanguardism

We have seen that the revolutionist also believes that our respect for the arts should be diminished by the death of vanguardism; however, stating a few evident facts removes the sting from this death, hastens the demise, and helps us find strong support for continuing admiration of the arts.

If we accept the view that art serves the various needs that our philosophers, psychologists, and anthropologists say it does, it may be seen further that some of the needs to which the arts can respond are bound to be new and vitally important—for example, the need to confront man's possible nuclear annihilation, to grasp an especially difficult view of the universe as energy and system. Some of the needs are bound to be old, recurring or continuing, and also vitally important (e.g., to confront one's own mortality, to think through symbols, to communicate with one's fellow man). Clearly there is no way to arrange all the needs hierarchically; we cannot rank vitally important, perhaps indispensable needs; what comes "first" when nothing is omissible and all are required for living? There is no way to rank art-doings hierarchically on the basis of the newness or oldness of the kind of need they fulfill. Vanguardists tried to do this in favor of art serving new needs or needs they deemed most important to the evolving of art itself, or to the culture, but we see that in theory this was inevitably wrong. It was also wrong in practice in that it denigrated all but purportedly avant-garde art, and hence impeded

many of art's possible services to people by blocking the production and seeing of the denigrated art forms. These, added to the above-mentioned ones, are good reasons for the death of vanguardism.

Thus I am reiterating that there is a broad range of services, recurring or continuing, that art can perform for people as well as new services. The artist who seeks to render one or several of such services is not made useless by the death of vanguardism; whatever the vanguard did or does, there are inevitably also other wants, neglected by the vanguard, left to be fulfilled. The artist, therefore, can still have a sense of purpose, stemming from the realization that he does useful work.

Another good reason for the death of vanguardism, one that fosters respect for the high arts, is the rightness of the displacement of the sense of linear time by that of the oceanic. That displacement is a real possibility. Perhaps most westerners will not move toward the oceanic time sense because of Oriental influences or those of the counterculture, but substantial developments in mainstream Occidental society may nonetheless foster the oceanic rather than the linear sense. The former is, for one thing, more congruent with a reality in which distant points in time and space are being brought and kept ever near us by way of our electronic media and keen sense of history, thus making art and time past resemble an enveloping ocean. Such points are no longer forever bypassed as by the head of a marching column or stream, this because we carry our "museum without walls," which embraces all art, with us always, and we are forever in touch with our fellow "global villagers."[2] The media make "foreverness" almost inescapable through their information and image storage and retrieval capacities.

This oceanic sense has some practical concomitants we can welcome, such as, for example, regarding artists as complementary high points in a cresting, subsiding, and capacious ocean rather than would-be heroes fighting for

the few places at the head of the advancing army. Also, in this time sense, there need be no attempt to render some sorts of art obsolete, bypassed by time, leaving some needs unmet. A broader pluralism can obtain. The frantic efforts of artists to leapfrog over their predecessors can cease. High and other arts are never rendered obsolete by oceanic time, thus a broader range of services, a broader base for respect, and more room for natural and diverse artistic growth and development can result from the death of vanguardism.

It may be objected that if one is not looking toward doing new, exploratory things as in vanguardism, he must endorse doing repetitive, old, routine things as in academicism, and the arts are then not respectable at all. But these are not the only alternatives among possible choices; one can ask, freshly, openly, and recurringly (i.e., not as an academician), "What do I think it right to do today? What do my needs, values, interests, environment, community, and so on, demand?" In response, one can be open to doing whatever is called for—possibly involving new things, possibly old things. The death of the vanguard does not leave us with the undesirable academic posture; it merely eliminates the view that insists that only new things are worthwhile.

This brings us to the nub of an ontological issue posed by my position from the outset. If "the meaning of life" (figurative sense) lies chiefly in finding the *meaning* in life (literally), and if "the meaning of art" (figurative sense) lies chiefly in finding and exemplifying art's *meaning,* then exploration, investigation, and statement are everything. But in talking here of the arts' relationship to needs and interests, old and new, I am taking a different position, saying that though, of course, curious, thoughtful, fully aware people reflect and explore, life is to be lived, not explored, and art is to help with the living, not only with the exploration of art or life. *To be* is the reason for being, not *to explore.* Hence the death of vanguardism is only the demise of an

unfortunate compulsion to identify all of life and art with exploration. I shall not argue this view further here; if our opinions differ on this, I suspect that no argument will be of any use, but it is well, perhaps, to make the issue explicit.

Against Anti-Anachronism

The above argument speaks to the charge that the high arts are not for our times, for, I submit, it is in order to remain free of the particulars of one's times, and thus to be responsive to recurring and persisting as well as new needs, that painting and sculpture are of course anachronistic, meaning not noncontemporaneous but rather not limited to current thinking and conditions. To think that the arts must be continuous with and thus bound to the technology, philosophy, and life-style of the world around them is to misunderstand their possibilities and usefulness when free of such a belief. For art is better enabled to serve people by standing free to make a new reality than it is by being bound to conform to a current reality.

Moreover, it should always be evident that, theoretically, current reality and statements about it hold no implications for the arts and artists; that they never have so held and never will; and that the arts are in no way obliged to reflect or conform to what is, because propositions about reality are not ethical statements, telling one what one should do.

Why has our freedom from obligation to the historical present not been evident? Perhaps because we mistakenly identify the proposition "Art reflects its times," with the admonition, apparently addressed to artists, "Art should reflect its times." They are not identical. The admonition says that one has an obligation and must attend to it, attend to it to assure his art's contemporaneity. But the proposition (a truism, I believe) says that art does reflect its times, presumably even when fulfilling long-continuing or re-vivified old needs. And this has indeed been the case; even *apparently* noncontemporaneous works, for example,

neo-Gothic ruins built on English industrialists' estates in the nineteenth century, are now understood to be responses to the then-contemporaneous need to escape from that century's encroaching ugliness. Therefore, the admonition is not necessary or even sensible; indeed, even stating the admonition is foolish if the proposition is true; one need not be admonished to do what he cannot help doing. The admonition only displays our anxiety or lack of imagination; one fears that the inevitable may not happen unless one sees to it, or one fails to see that the variety of things happening are indeed, in every sense, contemporaneous. But the statement "Art should reflect its times" is theoretically unsound.

Moreover, the admonition to be attentive to contemporaneity may well be practically disadvantageous. It appears to suggest that one look for direction from a historical and cultural assessment; but does one really get genuine contemporaneity by, *at the outset,* noting, interpreting, and deliberately reflecting one's discernments, or does one, rather, do better by moving toward his desired goals as if anything at all is thinkable, permissible, and possible, leaving concern with reality, history, and culture aside and meeting the limits of the possible only *at last* and noting one's inevitable cultural-historical entrapment only *ex post facto*? This is not something provable, but I lean toward the latter view, because then conduct would be based not only on judgment, but on all that contemporary life, past and present, has made of a person—on the assumptions it has given him, the feelings it has generated, the interests it has provoked, as well as from his assessment of what the age demands. Attention to contemporaneity would seem dysfunctional.

I am arguing that one is, and must be, a contemporary man, and though one does not escape history, culture, or current reality, he would stand best if he stands as if he could make the world afresh; stands so as to find the limits of the possible at last, not at first; stands so as to transcend

reality, so that *he can do so* to the extent possible in one's time. To stand so would not make practice unrealistic, or unsuited to our times; our arts would then have real current usefulness to human beings, through standing free of concern with conformity to historical reality or contemporaneity and open to determination by new and continuing needs and interests. One need not believe that the high arts are necessarily useless in our times because all their forms are language-related and have been explored.

To return to the ontological issue. Perhaps it is true that "all works of art conform to five types of sentence structure"[3] (Burnham), that the meaning and mode of being of all art forms are basically linguistic, and that all linguistic forms have been explored. Does this preclude justification for continuing in our time to make such forms? When one has said what art objects conform to (i.e., language forms) and what they exist *as* (i.e., language), one has said nothing about whether the existence of such things is justified. One may justifiably create an object not to exemplify a particular sort of conformity (object-to-linguistic structure) and not to bring into being an example of something in some particular (its own) mode of existence. Rather, one may need this creation to come about for one's own reasons, to serve himself and society quite aside from its linguistic and ontological exemplifying capabilities. This need would justify the being of the object. Perhaps most of us have not seen this because we have long assumed that artists and artistic forms exist to explore art; but just as I may cry "Give me water!" not to *explore* sentence structure but to save my life, so I may paint not to explore art or exemplify its possibilities, but to use its services. These services are, as noted before, quite various and include response to persisting and recurring needs. Art that performs such ever-needed services is, then, not noncontemporaneous; it is good in and for one's time.

Paintings' Contemporaneity and the Marvelous

Perhaps the most insistent accusation that the high arts are inappropriate for our time focuses on the art of painting, for that is the art for that seems to many people the most out of keeping with our era. Painting is a manual art—in an age of advanced technology; an art of (alleged) illusions—developed in the Renaissance; an art of romantics—in an age that has outgrown romanticism; a very limited art, physically, in an era when men can move mountains (even to museums).

The retorts given above hold, I believe, for painting as for any other art; by standing aside from deliberate conformity to its times, painting becomes serviceable to old and new needs in its and other times. But some misconceptions are preventing people from seeing one great contribution of painting in particular, one available always and making paintings always contemporaneous. That contribution is the experience of the transcendental and the marvelous. Let me clear away the misconceptions, affirm the strength I see, and thereby enable a response to the charge of noncontemporaneity.

It seems clear that people of all times reach out for experience of transcendental forms: they travel to allegedly numinous places, take drugs to make their environs transcendental, stare at the sun or their navels to experience the world as material-surpassing, and so on. And, with far less trouble and pain, they have experienced the transcendental by looking at paintings. That is, people have seen color on flat canvas giving the appearance of depth, of meaning, of vitality while remaining pigment in hardened oil or plastic on cloth. They have seen edges that, literally static, seem to move; areas of paint that, although at one (room) temperature, seem relatively warm or cool; dead paste that appears to emote and tell. Paintings, that is, are material

things that surpass themselves *as* material to become also something else; in this sense a painting is transcendental. And for this quality paintings have long seemed well worth seeking out. There is no reason why they would not continue to seem so and thus continue to be viable for our times, if we are not led to distrust their phenomenal powers (or qualities). But we have heard that these phenomena are illusions—and therein are phony. They could not, then, be anything we still need today.

However, in fact there is not now and never has been any illusionism in any work understood to be a painting. For centuries we have just sloppily misapplied this word *illusion* to art. We saw something in art that was, like an illusion, extraordinary, and we then equated two different things. To stop this, let us contrast illusions with paintings, to let the differences be understood.

With regard to illusions: a) an illusion appears as coextensive with our everyday world: a real rabbit out of a hat you could wear, a real oasis in the desert you traverse. The illusion, to be such, must be clearly so given; it must appear as part of the natural world, though possibly with natural law violated; for an illusion would not be regarded as such, would not be illusory, if it did not appear as a (possibly extraordinary) part of the ordinary environment. The illusory is the deceptive in and about the world.

b) The illusion's appearance is single-sided, a simple, bold-faced sight: a body floats in air, an oasis is, and that's that. The event we see seems to occur just as we see it, and we see nought in addition or contrary to it. We may know that more is involved, that what we see is impossible and that this is not really occurring as seen, but we don't see the wires, mirrors, or effects of light that would reveal the sight as a natural, possible one. We would not regard as illusory a sight whose means of appearance was evident and explained the sight in natural terms. The illusion's means of appearance are, then, covert.

c) When we know that a given appearance is an illusion,

when, that is, we are not experiencing hallucinations or mistaking mirages for reality but are, perhaps, at a stage magician's performance, our sense of appreciation stems from seeing the purported and apparent suspension of natural law by means unseen and unknown. Since we do not believe in magic, we are impressed by the cleverness of the deceiver who can, insofar as we can see and despite what we know, make the impossible happen.

In point-for-point contrast, consider paintings: a) a painting presents an image or sight evidently given as such. While the work is, of course, made of canvas and paint, matter like other stuff around it, what we see as the pre-sented image—Michelangelo's Jehovah, Picasso's fractured mandolins—is not given or taken as an extension of the surrounding everyday world. The water of the seascape obviously cannot join that from your dripping umbrella, and you see that you cannot swing your arm past your nose into Courbet's air-space. This is conspicuously so: you know that you are seeing a painting, an image-presenter doing its presentation by means of paint. The painting displays, then, a sight to be seen as such, and while it may make reference to the world, it does not appear to extend that world by the length or the truth of its image, or, in some possible or impossible way, to add the artistically achieved effects to those of continuing natural phenomena. The image presents no deceptive or true appearance of reality, since it is not given or taken as being in or of workaday reality.

b) In that a painting appears as both paint, or stuff with *its* qualities, and an image, or sight with *its* qualities, the painting's appearance, we may say, is dualistic; we see pig-ment which, while obviously inanimate, also obviously has vitality; pigment which, while evidently unfeeling, also ex-presses; pigment which, while clearly unmoving also dis-plays action. The painting has two coincident, co-appearing aspects. And it does not hide that aspect, its materiality, by which its other, its image aspect, is made manifest. The

means of the painter's presentation are, thus, overt and visible to all, if not perceived understandingly by all.

c) In fact, it is this two-in-oneness, this duality, that accounts in part for our wonder at and appreciation of a painting. We see matter that seems to be itself and be more or other than itself at the same time. Appreciation of the painting depends upon seeing two evident realities contrasting and differing from each other but coinciding and co-appearing. And this duality must persist if appreciation is to exist. The paint must be seen as paint, it must not seem to *turn into,* say, the water of the seascape and no longer be paint-and-sea concurrently. For then we would begin not to contemplate or appreciate, but to act, to respond (as to water). The painting, then, to be taken as art, cannot be successfully illusionistic, cannot seem to be *only* something other than paint.

Match these two descriptions and the differences become obvious. These differences are between deceptions in and about the world, by means unrevealed, to apparently create a marvel, and, on the other hand, constructs of an image or sight, aside from the natural world, by overt means, being marvelous (not literally a marvel) in having a dual, or two-in-one appearance. In that art and illusions both involve appearances other than the workaday, they have something in common but not much; they are not at all the same thing and cannot be identified.

Let it be clear that in alleging duality and marvelousness rather than illusions as qualities of paintings, no suggestion of strange or mysterious things is involved. To say that an open configuration of paint exhibits feeling, one of tension, while being dead stuff, is only to say, as Gestalt psychologists do,[4] that one's vision works toward closure of nearly-closed configurations, and that when such closure is difficult, tension-in-the-configuration appears; the form appears as though "wanting" to be closed but not getting to be what it wants. There is, then, nothing mysterious about this sort of apparent tension-in-dead-stuff. Studio lore has

long included notions about how to make colors
"vibrate"—while color remains unmoving; how to get
"dancing" lines, and the like. These are phenomena under-
standable in psychological and practical terms, requiring no
mystical or romantic orientation.

Indeed, I may put these phenomena into another famil-
iar frame of reference: what we get when this dualism
occurs is often, in the largest sense of the word, a *symbol,* that
is, matter and meaning in coincidence and coexistence, a
thing that is mere stuff, but that also has feeling and import.
I have been stressing here only an aspect of the symbol-
perceiving experience: that is, to see the two-in-oneness,
the matter and meaning in coincidence, is to see something
appearing wondrous, a self-transcending form. Often writ-
ers emphasize the value of the *meanings* coming to us
through symbolic forms (for example, we hear that we get a
soul-state, or the affective life revealed), but I am stressing
that any meaning (or vitality, or indeed anything nonmater-
ial) in dead matter is itself marvelous, and as such, marvel-
ous to behold, quite aside from the worth of the meaning
itself.

When we see this, we see why even old paintings now
remain marvelous and in this respect contemporaneous. A
new work brings the impact of its specific meaning and of its
perhaps new art orientation, and this impact disappears as
one "gets the message." But the aged work may still remain
marvelous because meaning-and-matter-in-oneness ap-
pears so, though a work's particular meaning and the ex-
ploration of its kind of meaningfulness no longer interests
us. Presumably that is why we still look at Rembrandts—not
to get the news, but to experience an ever-marvelous
phenomenon.

This point speaks to the objection that paintings cannot
be for our times when they deal with things about which all
has been said that can be said: figures, fruit, squares, scrib-
bles, and so on. The objection ignores the fact that the
self-transcending object is sought for just that quality of

itself. Precisely *what* is transcended seems not to be a point of interest; the experience of awe, of things self-surpassing, of whatever sort is the thing desired. So while it is perhaps true that nothing new can be said about the human body or still-life objects, every time dead paint "becomes" person or fruit bowl, a wonder is therefore created, and the strength of *it*, in addition to or irrespective of the painting's other strengths, is real and valuable, and must be valued in any time.

When this contribution of the marvelous is understood, another point can be made that makes the painter seem still contemporaneous and as advantaged as other artists who use more evidently contemporaneous, technically advanced, means. When the marvelous is appraised in given cases, recognition of one of its laws is necessary; moreover, such appraisal and recognition evidently occur. That is, when the capacity of the means appears to be great, or at least equal to the task of producing the end result we see, however grand that end result may be, we get little sense of the marvelous. We say, as it were, "*Of course* those big, strong, technically advanced, complex means could produce that result. There is nothing to wonder at here." On the other hand, when the capacity of the means appears small and unequal to the task of producing the end result, yet the end result *is* produced, we do get a sense of the marvelous. We say, as it were, "Look at that! Someone has gotten a person, a character, a being to come alive—with only some pencil marks! How in the world. . . ?" The *degree* of transcendence, that is, how much something becomes "more" and "other" while remaining itself, is the measure of the marvelous. Of course a big and good result may be appreciated as such, however it is produced. A city planner may use thousands of men, great machines, the resources of a state, and produce a city that we appreciate, but it is not an occasion for wonder. We expect—we do not wonder —that an elephant will give birth to an elephant. But the gap between what, say, a pencil line *appears* capable of doing

(i.e., very little) and what indeed it has done (say, in Ingres's hand), that gap *is* the occasion for wonder. And so, in this matter of producing the sense of wonder, the artist using limited means is not *therefore* disadvantaged, and the artist using advanced and massive technology is not in all ways advantaged. The means of each may transcend themselves, but it is the degree of transcendence, not the end point, that determines the degree of marvelousness in each case.

The arts of painting and sculpture have an advantage in this matter, namely, their materials: paint, stone, steel, plastics, inks, and the like, seem modest indeed and so great possibilities for transcendence inhere in them. Of course, if one wants to make a new city or embrace at one time an audience of thousands, the matters of transcendence and the marvelous are not at issue and one should proceed, losing some advantages, by other than the means of high art. But one generally gives up something when he gets something in art, and high artists get a great deal—the possibility of the marvelous—when they abstain from using massive, complex means. The modest means of these arts, then, is one of their strengths, and the oldness of these means does not make their usage noncontemporaneous.

Nor do the intimate and personal qualities of the painter's means speak against them even in our age. When one teaches, he often notes these days the ill-at-ease feeling of some young artists when they produce paintings rather then, say, television programs. But we may see that though the TV program extends well from, and is physically close to, the new electronic, everyday world, the arts of painting and sculpting extend well from, and are closer to, what *we* are as bodies and minds. The interface between ourselves and the physical world has many layers, and those closest to us are not thereby disadvantaged. The head of the hammer conforms to the nail and nailing; the handle conforms to our hand and handling; both types of conformity are needed. If an art that is continuous with our electronic world is privileged thereby, that is, by closeness, confor-

mity, and truth to that reality, art that is continuous with human bodies and processes is also privileged by closeness and truth to *that* reality. Painting is great because it works hand in glove with me; television is great because I see the world in it.

It is in the light of our discussions of dualisms that we may see the problem-contriving/problem-solving of the painter not as mere aesthetic preciosity and withdrawal from the world but as the making of a timeless occasion for wonder. We may see now that one could rightly contrive a problem (to create, as it were, a question or tension) and then resolve the problem (provide an answer or resolution of tension) expressly in order to display a two-in-one-thing, a marvelous dualism: problem and response in one form. It is as if one set up platforms and a high wire to be traversed by a high-wire walker: no one need care *where* the platforms are placed—the outset and destination of the trip are not of interest, no message is carried, and the travel is unnecessary, but the whole thing is set up so that we may witness the marvel of problem and response, tension (in several senses) and survival-with-tension. Many artists' problems are contrived, it would seem, for a similar reason. And though such things are not new, the wonder of them persists.

All in all, we see that the art of painting, though old, is not noncontemporaneous; when the revolutionist says it is, he is simply wrong.

Arts Detached and Arts Engaged

We have seen that the revolutionist insists that our aesthetic impulses, given their persistence, should be expressed not in the high arts but in the world at large. This is obviously a major issue, one we shall return to repeatedly, but the main points to be argued here are that, first, as we have already seen, the door to the high arts should not be shut, given their usefulness, and second, as we may see now, the door to extended aesthetic practices should be used

carefully, for there are gains to be made by extension of aesthetic impulses into all of life and environment, but there are also dangers in, and severe limits to, this extension. Also, practice in the high arts, arts discrete and detached from the everyday world, cannot do everything that artists would like to achieve, but such practice also is exempted from some of the dangers and limitations of extended, nondetached aesthetic activity, and can yield gratifications of its own not duplicable elsewhere. Practice in the high arts, therefore, cannot be proscribed, and only cautious, discriminating practice of extended aesthetic activity can be recommended. The two sorts of aesthetic acts—those that are discrete and detached and those that are melded and coextensive with the world—should peacefully coexist.

I can begin to outline the argument for this viewpoint by raising some simple and obvious, but currently neglected, considerations.

Let us note that we can and do undergo experiences on a scale of degrees of personal involvement, ranging from, at one end of the scale, the psychic distance and detachment we feel when dealing with high, framed, or pedestaled museum art, to, at the other end of the scale, the engagement, the no-distance we feel when partaking of our everyday business. We recall that high art is indeed "detached, bracketed";[5] even when the works are *about* life and reality and even when influential in the world, they are given as things set apart for aesthetic regard, for contemplation. By contrast, everyday business—eating breakfast, caring for a child, getting to work—normally does not distance the participant from the act; we are physically and psychologically engaged in it, responding, willing, acting. Such everyday things *may* cause us to contemplate, but we do not regard them as things given for contemplation, for indeed, they are not so given.

And in between these ends of the scale—precisely where does not matter—are such things as parades, pageants, rituals, demonstrations, Environments, Happenings,

Street Theater, Life-Art, and so forth. That is, there are things where artistic-aesthetic concerns are mixed with other concerns but are quite important, and where the distanced-contemplative posture occurs to a considerable degree.

Now, about each of the several sorts of thing on this scale of experience we can (but seldom do) ask: "What factors are the determinants, the limit-setters, of this kind of experience? What are they for a painting, a poem, a street demonstration, a conversation? What advantages do production and participation in each kind of experience have; what can each achieve; what are its inadequacies, its side-effects, and its liabilities?" If we ask such questions, a new light is thrown on this problem of aesthetic extension.

For one thing, it becomes clear to us, as it has to people down through the ages, that when one acts out in the world, the moral-practical sort of attention must prevail over any other that may be involved. If all current moral codes and all extant definitions of wisdom and goodness were obliterated, most of us would still feel that we should do right by each other when we meet, and do right by mankind. This means that we have to consider what sort of taking and acting attitude is likely to yield good sense and common decency in a situation at hand. Usually this is self-evident and so we may swing along quite casually, but when a situation becomes problematical, we become aware that moral-practical considerations, not purely aesthetic ones, *should* prevail. This is not to say that the desire for making an act or a whole community "beautiful" should not count in our moral-practical considerations, or that we should give more weight to economic gain than to joy and loveliness, but to say that in a given situation one must determine just how important aesthetics is, and how important are other interests, and this determination *is* moral-practical.

This is to say that there is real danger in the argument that our aesthetic impulses should be extended into and over life at large, unless many cautions and the need for

moral-practical supervision go with the argument. We all have seen the danger realized in practice. For example, after World War II, city planners in New York cleared slums by tearing down old, shabby tenements and replacing them with new, allegedly prettier, housing projects. The planners were beneficent people trained in the design fields: architecture, engineering, and landscape architecture, and where they saw ugliness they wished to redesign for beauty. It is charged that they failed to give beauty, that the projects are ugly, but the major failure is that, in being designers and hence people posturing themselves aesthetically, they failed to determine what people really wanted and needed—good jobs, better education, hope for the future, and so on, things that *aesthetic* interest could not uncover or deliver to the community. Again, this does not say that that the housing should have been ugly, that aesthetics should not matter; but it says that moral-practical concern should have prevailed and determined how much aesthetics, economics, psychology, and politics should have mattered and what should have been done in practice.

That remains the case now; when one engages in acts that are coextensive with the world, he places himself and his acts under moral-practical consideration. One asks, "Should my Happenings break up my neighbors' dinner?" or "Should my street ritual spoil the Smith kid's baptism?" or "Should my Demonstration be in aid of Candidate A or Candidate B? And what will work best to this end?" And so on. One begins to see that the provinces outside of art are not to be entered thoughtlessly.

Moreover, the acts and objects in and coextensive with the world are subject to state laws and the countervailing wishes of other people, people who also may legitimately act, and who may act to ignore, support, or impede one's own actions. And good or bad and unanticipated *consequences* may follow from one's actions in the world. One must consider these seriously; this is not just "play-acting," we may say. Clearly, to act aesthetically or nonaesthetically

in the world is to subject oneself in some degree *to* the world.

Another obvious limitation impinges on acts that extend aesthetic impulse and interest into the world. In the real world one can do only what is in fact physically practicable, realizable, possible. The poet or painter can "realize" (though in a limited sense) God and Devil, heaven and hell, and he can make tangible, moreover, not merely useless fantasies, but situations he would like to try on for size, so to speak—situations (of attitude, feeling-state, potential reality) to be considered for realization if not realizable as yet. He can also confront situations which, though never realizable, are worlds of recourse he really needs to have. He can move through time and space at the will of his imagination and make anything real for regard. But the act in the world can do only what flesh and blood and glass and steel and the laws of physics allow.

This is precisely why there is no basis at all in the idea of art's extensibility for the belief that there need be no special discrete, bracketed things such as paintings and sculpture; that is, it is precisely because in everyday situations we must ask "What is the right and sensible thing to do?" and "What is it possible to do?" that the realm of high art exists. These arts are discrete from, discontinuous with, the everyday life, so that there can be some places where necessity, practicality, moral considerations, and consequences need not be foremost, where we can go aside **and** swing free and explore, imagine, dare, as we cannot **elsewhere**. We can do these things in the high arts *because* **of their** plasticity and detachment; we are free to mur**der—on** stage; think the unthinkable—in the novel; build a **surreal** city—in a painting, and so forth, because a realm of art exists, where laws of government and physics, and societal wishes and mores, do not obtain, and the imagination controls everything.

Yet, the limitations of high art's detachment and the virtues of extended aesthetic practice must be seen also, and this is the very point: that each sort of practice has virtues

and faults, and each can and should coexist. For example, although the painter can realize anything at all, he makes a thing real only *for regard*, something for the imagination to hold up for a look, and, though this may be practically useful eventually, it may be kept at such a psychic distance as to make its effect upon one negligible. On the other hand, everyday life is inevitably real, demanding, filled with impact for the participant, as may be the aesthetic acts coextensive with it. (Even such acts, however, can be taken aesthetically and thus made distant and with little or no impact). If, say, Max Ernst is not content to realize his fantastic cities merely as images, which make no real city really better, he must move out into the streets. If he opts to make life or the city better by action in the streets, he may achieve little—he will not complete a vista as he does on canvas—but what he does achieve will be real, full if impact, and public. Also, it must be acknowledged that much more is realizable than we normally admit. As Marcuse says, new technology and societal structures open many possibilities in the real world that we heretofore thought realizable only in fantastic art. Still, the real world is not so tractable or plastic as the arts, and presumably even in the best of worlds, laws of physics and morality will still obtain. And there will always be the *other* to interest us—an unrequited love, an extreme of delight, a change-of-pace world —attainable only in the arts. So we go back and forth between the respective virtues and faults of high art and extended art practice and see that each is needed, for we see that each works to certain ends and not others, and each entails gains of some sort and losses of some sort.

As we now look at that scale of experience, ranging from pure, detached, high art to self-involving, everyday life-conduct, we see that it is not *generally* and *theoretically* better or worse to work at one end of this scale than at the other; rather, one's choice must rest upon what he is seeking and what he can do with and do without. It would appear that privilege for a form is not universal but contingent, con-

tingent upon its fitness for the ends toward which we are asking it to work. The several forms do not preclude or deny each other's usefulness; they complement each other, to constitute a broad range of things to match up with a broad range of personal and societal needs and interests. The door to practice in the high arts cannot be locked, and the extension of aesthetics into life at large by everyone and always cannot be considered obligatory. Neither can a great degree of extension be considered illegitimate, if done morally, discriminately.

The Process - Product Controversy

In the above discussions the role in the arts of their products is implicitly emphasized; for example, the objects are the displayers of the dualisms one experiences as wondrous. We may, then, understand why the products themselves are continuingly made and valued as such, despite the current emphasis on process. This is not to disparage this emphasis. To Rilke an archaic Apollo says "You must change your life," and many artists have long tried to make works that say the same thing to others; if they can design *experiences* that work toward this end, they should feel highly gratified. I am only asserting that marvelous objects as such are not devalued by these conditions.

Also, we must remember that for many people the pleasures and benefits of involvement in artistic process can exist only when this process is working toward yielding a product. Very young children slap and mold the water at the seaside for the "process's" sake, but soon tire of this; then they and older children build sand castles for the process's sake, and they give more time to this, partly because, I suspect, their process goes toward making a product, however ephemeral, and the process delights because it is not just "making," but making *something*. Then, as older children and adults, with similar motion they may make clay sculpture, which again involves a rewarding process as

such, but one that must be a product-yielding process or it is empty. For usually processes, to be experientially good, require goals, necessities, and generative forces to shape them, give them direction and cohesion. The product to be yielded can be the organizing principle or germ of the process. One can, of course, chop wood only for the exercise; the body's need is then the organizing principle. One can model clay to experience plasticity for like reason. But the legitimacy of having process yield product is not withdrawn by an awareness of the process's intrinsic rewards, because the product remains good and the process is often improved by its organization toward a physical result.

Perhaps nowhere is there a better shaping of process toward product, and nowhere a better enjoyment of each and both, than in the arts of painting and sculpting. Hence the revolutionist's allegations in this matter really do not lead one to abandon all product-making, but only to recognize the virtues of both serviceable products *and* processes.

Our Political Ground

I must now admit that the services of art that I discern are, as Marcuse suggests, helping to maintain our faulty System, which is to say that the attempt, from the Marcusean standpoint, to close the door upon practice in the high arts cannot be readily repulsed. But this attempt has peculiar weaknesses that make counter-attack unnecessary. For having heard that no matter what one does he is in collusion with the System and that the System can digest, contain, and use *anything,* in effect we have heard that there is no special virtue (or fault) in making shoes or parks instead of paintings, love and underground movies instead of sculpture: all forms of art, nonart, work, and play are Systematized, so why move from one to another? To withdraw from the elitist art of painting and go into the democratic art of sandal-making does not make a person less System-supporting (nor, of course, does it really improve

society). Nor do new, widespread, aesthetic practices in themselves exempt us from being System-supporting; spread art to more people and art becomes more guilty, serving more participants of the System and thus sustaining it better. Even an alienated underground art, which seems uncontainable by the System, in fact supports it by being a relief, a safety-valve that helps the System endure. I see no convincing suggestion here for giving up painting and sculpting, and no good argument to make extended practice obligatory.

Is withdrawal from the high arts obligatory because art is intrinsically bad for society and must be redefined so as to be socially good? Few Marcuseans suggest that the high arts are necessarily and intrinsically socially detrimental; indeed this cannot be suggested, because it is clear that the same works we do now, if done within and hence in support of a good System, would be guiltless. Only if art had one function and this was "to obscure what is bad in daily life and to teach falsehoods," could art be called intrinsically bad for society. Though some art has indeed served precisely this function, most art has not. The potential for disservice in the arts is only one among their many potentials—one no artist need choose to fulfill. Hence art is not intrinsically bad for society, nor is it made so by the mere possibility of bad usage or occasional realization of this possibility.

This is not to brush the matter of social responsibility aside but to say that, if one feels responsible and guilty, he should work to change the System to something good, so that in being supportive of an existent society through his art he will be supportive of something in which he believes. Surely this is a better recourse than lying limp forever, and also better than reducing everything to uselessness by redefining things so as to have them now conduce to social justice. It makes no sense to redefine *shoemaking* to mean *making poor boots*—unfit for soldiers; and it is just as senseless to make of art something that would be useless when a better world is made someday by destructively redefining it

now so as to be useless to a currently bad system. It is better for us to work as political people for the world conditions we want, thus making the vocations supportive of conditions that, when realized, will be admirable.

Should some art be disallowed in favor of that which can work toward changing the System? One is certainly free to propagandize, disrupt, and challenge the System by means of his art efforts, but we hear no convincing argument that *generally* artists should use art directly to change the System, not when art operates so poorly to this end and when political action is possible and far more effective. Yes, art is good for (political) revolution, because it brings to people's minds the artist's sense of freedom from current forms and preordained orders, and this is to foster a fever in the population and the possibility of change. Spreading the art spirit is something that revolutionists and others can do; but the spirit underlies all kinds of art and aesthetic activity, and hence we hear no convincing argument for changing our art posture and production to change society.

All of this says that Marcusean analysis blows through our minds like a sharp wind, bringing insight, anger, and guilt. It also brings implicit instructions to change our politics, not our art. Marcuse rightly makes us all feel wrong, hence revolutionists rush to alter their own lives and ours; but even in full admission of his views, he really makes the art no less right nor other practices privileged. The right to practice both detached and extended forms remains.

Thus far we have seen serviceability and strength in the several arts, making all legitimate and none exclusively obligatory. But the question now arising is, "In defense of practice of the arts, must we defend the art world and *its* practices? And can we?"

Defensible Arts, Indefensible Art World

The position on this is simple: I find no way to dispute the

revolutionist's charges against art-world practices, but there is also no need to in defense of the high arts. My concession admits only that the arts have some potentials for bad usage and that these are currently being fulfilled; while such potentials are not to the arts' credit, it is the options people have taken for fulfilling the bad potentials that must be our target of attack, not the arts themselves, which have some good potentials people could choose to realize. I say that people, not the arts, are discredited by the conditions in the art world. So I agree with the revolutionist in his appraisal of art-world conditions and practices, but decry his labeling of the arts as bad because badly used now. This position seems not subject to objection and hence not worth arguing: one really cannot advocate damning potentially useful things because they are currently misused, and one must advocate movement toward better usage if current practice seems poor.

However, while I will join the revolutionist when he makes proper moves against poor art-world practices, some of his thrusts seem objectionable and need culling.

First, on elitism: There will be no effort here to defend elitism, or to deny its presence in the art world, but I have reason to believe that to insist that everyone is an artist is the wrong way to defeat elitism. The fact is that some people do seem able, in a high percentage of their efforts and at a high level of quality, to succeed in their aesthetic, giving acts, while others do not. Even if I refrain from calling the former "artists," and even if hard boundaries between art and nonart, successful and unsuccessful efforts, are erased, this will not erase all distinctions based on talents and abilities, and elitism could still thrive on such distinctions.

The revolutionist is also wrong in thinking elitism may be obliterated by insisting upon only types of art that all can make, understand, and enjoy. We know that this idea springs from the belief that difficult and esoteric forms are deliberately made so, and hence are made exclusive. There is little evidence to support this view. Rather, it seems that in

my field, as in others, some searching, profound, and provocative works have to be created, and have to be difficult in that few people are prepared for them. We might stop granting theoretic privilege to difficult works just because they are difficult, in an effort to reduce elitism, but they are clearly serviceable and hence not proscribable. We can not diminish elitism by insisting that art be homogeneously easy.

Moreover, the revolutionist's attempts to reduce elitism all miss the mark when directed at people's philosophies of art, art practices, and achievements, for it should be obvious that people are elitists not because of their beliefs, or distinctions, but because some psychological needs drive them to find grounds for labeling themselves superior. Apparently, many fraternal orders, honor societies, and fancy leagues are formed to render ego support and a sense of identity through membership in an "in" group. One would guess that art's "in" groups are formed for similar reasons, not because philosophies or other realities demand them. If an art philosophy argues for elitism, we may well want to rebut it, but in fact where can one read that we are to crown artists as noblemen, see their humanity as superior to that of other people, or see them as sole possessors of sensitivity, creativity, and integrity? Not in any respectable philosophical volume. So the revolutionist is wrong in attacking other than the psychological weakness that fosters elitist practice.

It is silly to assert that the arts have an especially large potential for elitist usage and that this makes them bad. When driven, what can a person *not* use to make himself seem superior in his own eyes? Granted, big diamonds and old masterpieces are better for this purpose than old shoes and whistles, but people have always managed to create elitism on such bases as their respective races, birthplaces, hobbies, killings in battle, brains, muscles, houses, and so on. To claim that, say, paintings and earthworks are things capable of supporting one's elitist posture is to claim almost nothing.

My objections here are made also in consideration of alternative and better ways to assault elitism. It may be that, rather than assaulting the bad, we would do better to increase the good in this area. We could work to assure that a wide range of art is offered to a broad public, a range wherein all people may participate and all art-related needs may be serviced. We are now prepared to see that in theory we already have such a range, as we drop the theoretical boundaries between the high arts, academic art, avant-garde art, crafts, popular arts, life art, and so on, and cease to maintain hierarchical rankings among these arbitrary categories. Now we need only see to it that art and people of all sorts can get together and we will have the democratic participation we seek, without the cost of ruling out some forms or inventing new ones "for the masses."

On art as commodity: Though I share the revolutionist's views generally, I may take exception to his condemnation of those art endeavors which, because they yield portable objects, lend themselves to usage as counters and commodities. Again, bad usage by *persons* is the culprit. True, the artist cannot rightly ignore the uses to which his art is put, just as the scientist cannot, because his researches are pure, ignore the fact that the Pentagon is awaiting his reports. But the task, the imperative task, is to get out from under this misuse or change the system that perverts the work. There is no more sense in stopping the creation of paintings because they can be used as commodities than there is in ceasing to nurture boy infants because they may be used as infantrymen.

Moreover, to get our art out from under the System requires of us not that we abstain from selling art to the rich (who will always be with us and be among the aesthetically needy), but that we reduce art's potential as a commodity by making it available to all people as a noneconomic good. Later we will consider some practical suggestions to this end, but because we *can* do so, and thus avoid the bad and

realize the good potentials of art, the art objects cannot be condemned as being inescapably rich men's playthings.

On art as religion: We also must join the revolutionist in deploring the use of the arts and the art world as a secular religion. The only danger in the revolutionist's position in this area is that he and disillusioned former worshipers may try to dissolve the arts entirely because of their dismay over some people's continuing art-religious pretensions or over their own disappointment; to counteract the claim that Art is All, they may insist that art is nothing. My response is simply to urge that one may go from devotion-to-the-arts as-a-religion to the serious involvement any responsible person brings to a worthwhile occupation. We can take the attitude that commitment to a good and intriguing kind of work can bring a sensible pattern to one's days, if not to the Cosmos, and the giving and taking of beautiful and stimulating work can be elating and socially and personally beneficial even if it does not bring salvation. Thus, we may make reasonable claims, without flights of religious fancy, and we may do fine aesthetic acts without pretensions of piety. Religion remains to be found if one has been seeking it in art; it cannot be found there, but we cannot damn art because it formerly was or currently is thought of as a religion. Art is not "all" or "nothing"; there remain other, appropriate ways to think of it.

On art as entertainment: My only response to the revolutionist position in this area is agreement, with the afterthought that we do not want to let an anti-entertainment stance involve puritanism. After all, what a sad bunch we would be if we never rallied the tribe, beat the drums, put on the fine feathers! The job at hand is to make the entertainment aspect of art no longer a definer of the art enterprise, but this does not mean that that aspect may not enhance our world when otherwise defined.

On overvaluation: I also concede that the high arts are overvalued; because of the misuses just mentioned, value accrued to them that has no lasting means of support. The

misuses should go, and with them the value they added to art; a devaluation seems called for. But I take exception to the view that the arts have become worthless. When one is producing objects or events, goods or services, when he is making them beautiful, growth-inducing, or otherwise beneficial, he is doing something worthwhile and worth something. Unlike the person who says "Art is all over," we must somewhat deflate, not prick, the overinflated balloon.

And, as the revolutionist says, we need not only monetary but psychological deflation; considering the above arguments, the artist should no longer see himself as High Priest, Prometheus, or Superstar. His ego must shrink to a reasonable size. But we can take exception to the revolutionist's insistence that every occasion for individualism or self-assertion is an ego-trip, that one-man shows and signatures on works are proscribable. Some artists' works are only understandable in comprehensive showings. Tailors and shoemakers put *their* name labels on their works. Why not painters? Gestures asserting anonymity are meaningful only once; afterward they are boring and foolish. Surely there are ways of deflating egos to a strong-but-unswollen condition without crippling the practice of art.

In sum, my defense of the arts is not a defense of the art world. I say that however badly used art is now, it is guilty only of some potential for such usage and, while this is not negligible, it is not damning either; art's potential for good is real and fulfillable also, and it is people's failure to fulfill its good possibilities, not the forms, that must be criticized and remedied. Because the arts can be practiced in better environments and can be better employed, they are not damnable.

Art First or Life First

Having seen now that the door to high art practice is not shut, and that life-as-art is not the only recourse for expres-

sion of our aesthetic impulses and needs, we see that the possibility of life-as-art is only that, and the possibility of a life devoted to production of art objects remains that. The practical question really boils down to one's examination of a balance sheet on the gains and costs of each choice. But that is a point worth emphasizing: there is no overriding consideration that makes one or the other choice inescapable. This assertion reiterates an important thrust of the revolution: it says (at least) that high art is not of such overriding goodness and grandeur that it engenders the obligation to put one's life in its service. And, we must agree, art is not God, Humanity, Life, or any other Supreme Good, exercising dominion, but only a good among other goods, *each* exercising its call on us. Hence there is no moral obligation to shape life for art production.

However, there is also no way to preclude such devotion, and openness of choice remains because there is no way to close the possibilities in theory. Surely the choice of a life-style determined by a devotion to high art is not obviated by the fact that a substantial price is exacted by this choice. A commitment to do anything whatsoever exacts a price; the only questions are whether the commitment is legitimate and whether the thing done yields to the doer and the world enough good to warrant the price paid for it. We have seen that the "doing" of art is legitimate, and while costs and gains, to persons and society, may be argued endlessly, it does not do to juggle the accounts on this matter. For example, to speak of "giving one's life to art" as a personal sacrifice is (melodramatics aside) to forget the gain therein: the life is not drained, but imbued with meaning and organization it lacked before. And while communities may lose by a citizen's attention to art alone, the community can gain art objects and new visions. When reckoning costs and gains, one should remember that commitment *happens,* and the question is not one of judging whether that commitment is worth what it costs, but whether the cost of repressing it is worth the losses entailed by the repression. "Is a life

in art worth the cost?" Perhaps yes, perhaps no. "Is a life spent repressing one's wants worth the gain?" Hardly ever.

Of course, similar commitments to a life-style also occur and have their costs and gains; these commitments similarly can not be proscribed theoretically. So each of us attracted to high art or life-as-art must draw up his own balance sheet and give it the weighting and accounting he sees fit, for no universal overriding consideration dictates one choice or another. Neither is mandated, neither precluded; openness remains.

Objections to Freedom

A complaint must be noted here. The foregoing conclusion and the arguments that lead to it say that artists are not to think themselves bound by universal theoretic mandates; that one is not obliged to read into or follow orders from History, the Revolution, the Established Elites, or (I may add) Science or Philosophy. Of course, one may be— he can hardly escape being—interested in, needful of, moved by certain developments in these areas, and he may indeed find some absolutely compelling; but no item, idea, condition, or discipline is the inescapable and rightful sovereign or governor of one's—or all—art. It is precisely this nonappointment of a governor that some people may object to, those who expect a guide to be named and get no comfort from an outlook which, naming no guide, seems to say that one is free to do as he pleases. However, it seems to me that while one may reasonably expect to be told that he is not unguided—after all, we don't act or feel or find evidence to indicate that we are—he may not reasonably expect to be told that there is *one* source of guidance (e.g., revolutionary ideology, a science) or told *what* that source is. Careful thought simply does not lead one to do such naming, but rather to decry it when done by others.

As to my response to the legitimate expectation: the position outlined above never says that one is unguided or

that he may do as he pleases. Considering the choosing of art/life priorities and relationships: there has been no suggestion made herein, explicitly or implicitly, that one choice on this matter is certainly as good as another and so the chooser may be whimsical. We found, rather, that one's debate as to what is the right choice is not something settled conclusively by the revolutionist's (or Establishment's) arguments, but this means not that whimsicality may prevail but that one's decisions remain to be made, and made through his unlimitable reflection on those many cases presented yesterday and today on the good life, its relation to the state, the arts' possible roles in the world, and the like. It is not that openness means herein that one may do as he pleases, but that he may consider what is the right thing to do, unbound by foreordained universal mandates—and unaided by them.

And what does my position say about guidance when we consider situations wherein one must choose among numerous high art forms and extended aesthetic practices and where one has not made a prior life-style commitment that limits one's choice? My position does not say that one may do as he pleases, but rather that, since no universal mandates and no life-style commitments govern choice of form, one's option must stem from a consideration of the specific situation at hand, what is to be accomplished in it, and the potential advantages and disadvantages with regard to the task at hand of the various act-possibilities available to him. I say that the kind of high art, low art, life-art, or nonart act that is right would be the one having the greatest potentials for achieving what needs to be done. For example, I noted earlier that high art forms, because discrete and distanced, allow for maximal freedom into flights of imaginative inquiry, inquiry free of practical limitations and consequences, morality, law, and so on. If such flights address the task one faces, then high art forms are privileged in this situation. If, on the other hand, changing some people's behavior within a short span of time is one's

need and goal, then some life-art or extended aesthetic practice promises to be more efficacious and hence such would be privileged in the situation. My position means, then, not that one may choose forms or act any way he likes, but that privilege for an act or form is contingent, and that one should appraise the fitness of various act possibilities for the tasks to be assigned to them, and so find out what is proper. This is not, then, unguidedness, though it is not guidance by a designated governor.

Thinking in and about art is, in my view, not unguided, but even if it *were,* this would not mean that the person is undirected, for it must be obvious that human action is not directed by taking thought alone; if taking thought were eliminated, there would still remain to direct us drives, hungers, instincts, environmental stimuli, and so on. After all, without *concluding* anything, people feel like or are moved to do so-and-so, this testifying to direction of behavior by *something,* even when reasoning is not governing. And if, as urged before, we regard people's needs, interests, body/environment relationships as substantial realities, not mere fluff, then these sources and sorts of direction yield guidedness.

What my sense of openness means, then is not do-as-you-please capriciousness, but free-flowing channels of thinking and feeling and decision-making, involving many sorts and sources of components; it means channels not frozen up by theoretical mandates from one source. This is not arbitrariness or unguidedness. If what it is remains fearsome to people who want sure guides to rightness, I can sympathize with these people, but cannot respect their wants or shape an outlook in response to them.

To sum up, if one holds the position argued here, what attitudes and beliefs is he maintaining? In this view the arts are seen not as a category or realm but as endeavors serving people in a variety of ways. Forms detached *and* life-entwined he sees as serviceable and therein worthy of respect. He sees the vanguardist posture as not mandated,

but he supports openness to serve needs and interests, however novel or familiar they may be. To him, the arts are helping one to be; they are not only explorations, of art or being. He gives recognition to the marvelous in the arts of modest means. He endorses ready access for all to the arts and recognition of the aesthetic in all of life, but he also recognizes that rightness and sufficiency in art-giving and life-giving are indispensable and that life does not involve aesthetic concerns only. He believes that artists should work politically to change the System they deplore, but should not kill their art out of guilt. And he wants a different art world, one that does not misuse art and does not disserve artists and public. He believes that art forms are each privileged in and for what they can do, and not universally. He believes in an open choice of life posture, made in recognition of recurring reflections and occurring drives. Such is the position one holds if he is convinced by the above arguments.

But it is one thing to be convinced of this outlook and to think in accordance with it, and quite another thing to realize it in his behavior and in the world around him. To this problem we turn now.

3

Action Toward Transformation

It is obvious that the art world is run as a free market economy, and that commercial, and thereby further, recognition is largely based on financial considerations, competitive politics, and individualistic exercise of power. To deplore this situation is to rant against the inherent contradiction in the role of the professional artist, who may or may not have a specific audience in mind, but whose commercial and professional audience is probably not the one he is working for.

—Joachim Neugroschel
Review of Turku Trajan
Art-Forum, 10, no. 4
(Dec. 1971): 89.

In taking art as seriously as scientists take science, artists refuse to play the game of art world fads. They are declining society's role assumption of "showman" unwilling to subject themselves to name-fame competition. The shift from object to concept denotes disdain for the notion of commodities—the sacred cow of this culture. Conceptual artists propose a professional commitment, that restores art to artists, rather than to "money vendors." The withdrawal of art into itself may be its saving grace. In the same sense that science is for scientists and philosophy is for philosopers, art is for artists.

—Ursula Meyer,
Conceptual Art, (New York:
E. P. Dutton Co., 1972),
p. xx.

At the outset it was alleged that our thinking about art and the conditions in which the arts exist both need radical alteration. Recommendations for changes in thinking were submitted above, and if they prove convincing, radical alternatives of outlook will occur. But it is possible that, quite irrespective of how many people are convinced, conditions in the art world will remain as they are or as they are now becoming, for action, not just thinking, is needed to alter the real world. So we must concern ourselves with action now. Of course, some action to our liking is occurring, undertaken by people in the revolution to realize *their* ends, but often realizing ours also: for example, those efforts which oppose museum domination of art and take art out to people of all kinds. In addition, however, there is another major sort of endeavor we might undertake to express and realize the position stated above. It is in many respects only a new construction put upon continuing efforts. It is not inescapably implied by my conclusions, but it is a reasonable recourse to take toward fulfillment of them.

Artists Redefining the Art Enterprise

My suggestion is that artists should redefine the art enterprise, by actions and in situations to be indicated, so that it is no longer considered an economic endeavor but rather is considered a service profession, one that is to be subsidized. Their actions should indicate and assure that the enterprise is no longer to be considered and operated as an elite business or an idol-making religious/entertainment world giving high-priced goods for sale. It is not to be an enterprise that, because narrowly defined, necessarily employs few people, but it is to be considered and operated as a profession where aid to a needful clientele is the task at hand—and the clientele's size is determined by the incidence of need (for beauty, mind-expansion, or whatever); the

practitioner's success or failure rests on his ability to serve the clientele, not on their position in the world or ability to pay. The means of supporting this proposal through the positions outlined earlier may be evident, but let me present the argument explicitly and let me add additional considerations as needed.

We will see below precisely what the artist may do, and in what circumstances he may operate to effect this redefinition, but several things immediately recommend this redefining generally, however it may be expressed.

We tend to define enterprises as religious, economic, political, aesthetic, educational, and so on, through consideration of their respective ends and reasons for being. But then it would seem that the art making-and-taking enterprise as a whole must be defined as noneconomic, not because of any mere preference for a noneconomic emphasis, but because, although the enterprise obviously exists for some reasons, those reasons are clearly not in fact economic. The enterprise, seen realistically, is an economic failure. Despite the great monetary gains of some few people, an enterprise must be regarded as economically failing when as a totality it involves great waste of materials and manpower, little profit for the amount of labor input and capital investment, high unemployment and low wages, many capitulations of firms and persons—in sum, much greater economic losses than gains. In all, a redefinition of the enterprise as other than economic seems warranted, because any business as bad *as* a business as this one is, is best regarded as something other than a business; the thing's reason for being, we should see, is surely not economic.

This leaves us with the question, "What are the enterprise's real reasons for being?" Considering the relationships we have noted between the arts and human needs, it seems sensible to think of the arts as existing to render services to people, through objects and acts. And it then seems sensible to consider art practice to be a service profession. We do not say that artists perform services in the sense

that waitresses and repairmen do, but when they make or do things that advance, elate, stimulate, delight, and expand people, they are serving them, and in this sense they are in a service profession.

This argument also indicates why I talk of subsidizing the profession. Because the art enterprise serves the ends named, it is clearly a very good thing, and because it is economically unviable it is a good thing in need of economic support. The subsidizing solution is the normal and reasonable one, the one we generally take in such situations. We do not normally subsidize *businesses,* of course, but please note a common attitude toward the service enterprise called education. We all want our children to learn (somehow, somewhere) how to get at the ideas of others, how to inquire, to create and construct, and so forth, and we think such learning is good even though some of it in no way benefits anyone economically, and the enterprise as a whole is not economically profitable. So we subsidize education; it is not expected to stand or fall on its economic merits. If now we see that through art new visions may be realized, environments enhanced, and consciousness raised, and that these results are good but uneconomic, then we can conclude that we should seek these things while we subsidize the effort, to the extent of our interest in and means for doing so. Our attitude here would not be an unfamiliar or generally unacceptable one.

Now, artists have been prominent among those giving at least tacit agreement to these ideas. For example, by asking for financial aid from governments, foundations, patrons, and the like, they have in effect said that art should be subsidized, and though they may want the money for quite personal reasons, they lay claim to it by asserting their work's contribution to the world. So the idea of art as socially service-giving and as worthy of subsidy is not unacceptable to most artists, judging by their actions.

But now I would like to make a proposal that requires not just tacit or even explicit belief, but action, with all the

burdens, costs, and gains the action will bring. Let me state the proposal for action and argue that its advantages outweigh its disadvantages to artists and to those things and people they care about.

The proposal is for action that would initiate the explicit and actual redefinition of the art enterprise as a service profession and would lead to the subsidizing recommended for it. I suggest that artists now begin to make their decisions as to the placement of their works mainly on the following basis: the objects and acts that artists produce may be adjudged in each specific case as apt for certain sorts of tasks, for example, a work might promise to beautify in some particular way or to raise consciousness in some specific direction. The works would seem, then, best placed where their aptitudes would indeed be exercised and where they would serve some people well thereby. It is to places and people discerned by the artist as optimal for this exercise and service that the artist is to deliver his work. He is to make his decision and place his work accordingly, with regard mainly to these considerations, not mainly for remuneration from the beneficiaries of his efforts. Naturally, the artist would like to get money or other goods in return for what he gives, but still, upon his own initiative or acceptable requests from others, he is to put his work where it belongs, and be paid if the client can pay and remain unpaid if the client needs the service but cannot pay. By doing this, the artist says that art objects and acts are no longer to be considered economic goods; through their becoming available in accordance with need, not wealth available, they leave the economic arena—and so does the artist. Thus a great step may be taken to redefine the art enterprise as noneconomic and as one primarily devoted to service.

What might the artist see as speaking for and against this proposal?

One thing at least seems to argue against this suggestion for the artist: he wants to live and earn his living as an artist, not some other way, and so he must see no sense in having

potentially less remuneration from art than he does now. Though the art enterprise may be an economic failure, he wants to make it a success for him personally, so that he may subsist as an artist.

However, though these *wants* are legitimate, the fact is that only a tiny percentage of artists do earn their living through art practice, and the suggestions made herein do not create or endorse or worsen this situation. I am not urging artists to give up a livelihood indeed earned in art. Moreover, the artist should recognize that there is no livelihood for most artists because the art enterprise is now defined in a way that assures this situation, assures unemployment. The artist, by his pursuit (or hope) of a livelihood through art, is playing the game as now defined and hence perpetuating it, helping to assure that most artists will be losers, likely himself among them. It is therefore to the artist's profit to redefine this game. And though his giving posture and actions would not be directed toward his profit, the redefinition they initiate could benefit him economically, by example encouraging other subsidies and new art clienteles. So this effort does not change for the worse the artist's actual economic situation, and it does hold some potential for improving it eventually.

The posture and action proposed should also recommend themselves to artists by the fact that they work to defeat certain evils plaguing us. For one thing, if artists want to subsist on sales, they must charge people for art objects and services amounts of money sufficient to buy food for a family for a long, long time, and only a rich few can afford to pay this much money for a work of art. Hence the artist who would subsist on his sales must deal with and work for only a rich elite. Even then, he must convince the elite that he is not to be paid merely as well as highly skilled labor—the artist would not get enough to subsist on if he were so paid, since he gets paid so irregularly—but on a much higher scale. And he must then say what justifies such payment, and so he adopts or creates fantastic theories and

mystiques as rationalizations. But if we recall the earlier discussions, it may be seen that if trying to subsist as an artist demands elitism and a life enveloped in hogwash, then the price may be too high.

The attitude and action proposed also alleviate the psychologically bad situation that prevails for artists when art is considered both aesthetic and economic. The artist is now moved toward schizophrenia by seeing himself in two mirrors, each yielding a contrary image. His image in his artistic mirror might be good, he might see himself as *artistically* very fine. His image in the economic mirror might be bad; he might see himself as an economic failure. The economic is certainly the clearer image, and he has always been taught that real talent and virtue are rewarded and revealed economically, so that he can hardly believe his good image if the economic one is bad. And yet he knows that the economic is not a reliable reflection, either; the art business is not notoriously just and his work looks very good to himself and others. So the artist walks about as a person of two minds about himself. One advantage, then, of the attitude proposed above is that it heals this schism: my attitude says that the economic mirror is a distorting glass, and breaks it. This enables a unified vision of what being an artist can mean and of how one may measure himself as an artist. Though we break the economic mirror for good objective reasons, the artist can see subjective advantages in the action.

Also, my proposal puts the artist in the professional's position, one wherein he is personally shaping his services as he believes they should be shaped, as opposed to being in the merchant's position of catering to the moneyed customer as if he were always right. In the new attitude, the artist puts work where and how he deems right and leaves this decision to no one but himself; this surely will be rewarding to him.

The proposed attitude also gets the artist out of the art-betraying and self-betraying position he is in when pre-

senting his works and services for sale as commodities. We noted above that artists determine the taking postures of their audiences by determining the modes of their art-giving acts; for example, giving utilitarian objects *as* art results in the objects' being taken as art. But of course the reverse also holds: hand a small steel sculpture to a man who wants to bang home a nail and he will take it *as* a tool. Now artists have long known that the taking of art objects by viewers as "economic goods" is a mis-taking. The art was not made for such taking, but for reception in the aesthetic mode of attention. But then artists must also have long known that *they* have been partly responsible for this mis-taking, known that by *their giving* their art works *as* economic goods they encouraged economic taking. And now, in the proposed attitude, artists may contribute to an *aesthetic* taking posture on the part of the receiver by proffering the art goods or services only as such, not as economic at all. Thus they may at last become true to their own avowals and true to what they produce.

So there is, in all, evident rightness and benefits to the artist in this redefinition of the art enterprise; if the artist takes on the burden of initiating the redefinition, he stands to gain.

I am saying that this burden *is* the artist's; his is the responsibility, the opportunity, and the means for making the redefining gesture. The enterprise belongs first to artists—it is *their* field—and if the people who are the chief practitioners in an enterprise will not redefine it, who will? Only the artist can submit works as noneconomic givens, and thus redefine and subsidize art in one move.

It may be said that there must be better ways of doing this, but although other ways may supplement this one, I do not see a replacement for it. I see no other practice that so well moves artists and art directly into the service category. The practice indeed renders services, and no other so well expresses and makes concrete the new definition and so well enables the artist to be a subsidizer and hence an exemplar

in this regard. If an artist is rich in anything, he is likely to be rich in his own art, so he can subsidize best through giving his work. And he can, in the suggested practice, start action *himself,* and be the main and final judge of its appropriateness. His moves to place his work will most directly afford him those satisfactions inherent in the new attitude. If others see better or different ways to get the redefinition I seek, I hope they use them with or instead of the practice advocated herein, but I cannot see them as yet.

The full advantages of this new way of doing can be appraised only in consideration of new possibilities it opens up for artists and public. For example, because artists are usually concerned about selling, they now often refuse to exhibit their work in colleges or small towns, and refuse to establish galleries and studios in other than rich metropolises, refusing even though they know that art should reach and benefit wider audiences and that their own studios are overcrowded. If they now stop being concerned about sales, if they stop making the profit-and-loss statement the measure of a single show or showplace, they make available new exhibition locales and new art-service enterprises, ones that will indeed get art out of the stacks in the studios and to people.

Especially to this point, with our new attitude we can take a fresh look at the viability of artist's co-ops, including cooperative galleries, groups of artists exhibiting together on special opportunity, and larger membership organizations. Such come into being because it is clear that in cooperation and numbers there is strength; a group can do things that most individuals cannot. They can rent space, publicize, seek grants, aid individual members, and so on. Yet, most often group organizations are currently considered failures. Why? Because they do not turn a profit; that is, they are "failures" because of their economic losses and the assumption that they should have been economic successes. Now, we say that a school fails if it does not educate, not if it does not realize a profit. Let it be so with art. We can

then say that a co-op gallery succeeds if it does what its members and clientele want, even if it does not realize a profit and must be subsidized. Obviously, this does not mean that the problem of paying the bills is a negligible one, but it does mean that exhibition, workshop, and educative, self-help, community-service possibilities are not precludable by real or anticipated economic failure, for economic viability is no longer to be identified with the endeavor's general and total viability. Now one can say "I may sustain this good thing if I can afford to," rather than "This thing is bad because economically unsound." It may be that such ventures can indeed be sustained, by subsidies from artists and others.

Such cooperative efforts (and others to be noted), because not bound to money centers, could effect a broader geographical and class-level distribution of art. True, it would be naive to think that everybody everywhere wants, or could benefit from, one's art, and that making art more accessible would plug it into all of American life (and there are dangers in this very possibility), but the needy eye and mind are where you find it, not just in one economic class or in a few cities. A wider distribution thus seems highly desirable.

Indeed, wider distribution makes possible a reduction of elitism and of usage of art only by the rich as their plaything, and it enables a greater degree of democratization.

I noted earlier that democracy in art cannot come by identifying everyone as an artist, and cannot come by one's insisting that all art be understandable by everyone, or that all forms should be nonmarketable ones, but it can come by making a wide range of arts, objects, and services available in all places and to all classes. This is made possible by the attitude suggested.

In sum, this new attitude lets us form cooperative and individual service efforts in store-front galleries, union and grange halls, community centers, hospitals, schools —wherever there are space and people. In fact, we can thus

have a scene-without-walls, an alternative to the main-stream scene. We can break art loose from its aesthetic ghettos, and break artists loose from running the mainstream's mazes. These opportunities speak for adoption of the redefinition proposed here.

We may note also that, without these locales and such a scene, advocacy of a redefined art enterprise is pointless: a service profession needs places in which to practice, and a clientele to serve. So, although these new opportunities are to artists' interests and exhibition opportunities are artistically advantageous, they also must be wanted as outlets for those of us who want the art enterprise's redefinition indeed implemented.

The University as an "Other" Scene

In addition to the above-mentioned locales, still another has in it the conditions and practices that could enable implementation of both the service motive and fulfillment of the artist's desire to show his work, namely, the university. Let me point out the university's potentials in this regard.

For one thing, almost every campus has some exhibition spaces, ranging from mere specifically designated lobbies and corridors to fine galleries to full-scale museums. Schools also often maintain exhibition and service programs, involving as participants faculty and local and visiting artists, having as audience many inhabitants of the area. By putting the new construction on the situation, we may see it as the extensive, extant beginning of an alternative Scene, in that it now provides art with giving-and-taking opportunities to many people outside the Mainstream.

Moreover, universities are tacitly granting the idea that art, like education, should be subsidized—and our Scene needs this admission. The colleges know that in teaching art the most conspicuous thing they are doing is perpetuating art and art teaching, but they also know that in so doing they

are gaining some good residue and fall-out; they are changing minds, enhancing personal and communal lives, sensitizing and opening up people in this student generation and those *they* will teach. This residue is clearly noneconomic, so the university is saying, "We support art; its viability is real though noneconomic." And if the university can recognize this its own tacit position, it can welcome an alternative scene in its midst. This potential is a valuable one for artists.

The universities are also generally well-established institutions, with states, patrons, foundations, and alumni devoted to their continuing existence and willing to subsidize them. That too makes them a good home to move into.

Also, the young people on campuses include many counterculturists, and these presumably would welcome our alternative scene if only because it is such. Art is welcomed among youth generally (although the art most welcome, apparently, is music) and by faculty, so a ready clientele awaits our efforts. Moreover, students can be considered a good audience for art if service, not sales, is our interest. One's college years can be and often are the time of greatest self-realization, enthusiasm, openness of mind, and thoughtfulness about the world. If the artist wants to have his art do the good things he so often talks about, there could not be a better population for his purposes than that of students.

Moreover, being a student may become a perpetual or recurring status, one involving a broad range of people. For better or worse, less and less of people's lives are being spent at jobs and more and more at leisure, and people are coming to think of self-realization as a fine use of leisure time.

Indeed, some day the university may be identified as the legitimate home of the counterculture, and people of all ages will go to campuses, for hours, days, months, or years, for recurring immersions in "other" culture, for retreats, for experimentation with alternative life-styles, and so on.

Even now many people are making campuses the sometime and recurring center of their lives. Hence a highly varied audience is available for our Scene.

Also, universities have all sorts of ties with other universities; their respective students and faculty intermingle; they confer on matters of mutual interest; they are used to acting cooperatively as well as competitively. And so our alternative scene can be a network of collaborating centers of artistic activity as many Student Centers already are, sending shows around, for example, or bringing services from one campus to another. Of course, no complicated permanent organization is suggested here, but a shifting, invisible net of cooperation can be woven and be useful nonetheless.

Moreover, with rapid travel and communication these days, no university is too isolated for the role I suggest. Jet planes, television, even auto travel, make the art and the people that are available in one part of our Scene, or anywhere else for that matter, also available in other parts. So our alternative Scene would be properly placed in any university, and this speaks well for the suggestion.

The university is susceptible to demands that they play the role suggested here; there are ways of realizing the potentials we cite, levers we can use to open doors. Student power is considerable and can be applied to bring to the university the art they want. Art's capacity to educate and to enhance life is acknowledged and this gives us a claim upon the university's time and space. There are ways of making these possibilities realities.

In sum, if this Scene is indeed created, in the university as well as elsewhere, we could then have a service profession with an appropriate locale in which to practice. That locale, the new alternative Scene, since it holds little economic reward, requires the service motive if it is to be realized, and the service motive needs a noneconomic ground on which to operate; they are made for each other, as it were. Then art can go anywhere, anywhere that need exists and that is

practically possible. Artists would take the lead in initiating and subsidizing this effort and defining its meaning; others, especially benefiting parties, would be expected to help. Art would be proffered as its makers intended, and artists and public would benefit in the ways noted.

Answering Objections

There are, of course, exceptions that one may take to the road recommended here. It may be argued that our path is likely to be unacceptable to some artists, because, for one thing, they will want to strive toward Fame and Fortune, will want to play the game for the Grand Prize, and must therefore reject any attitude that turns away from these things. Indeed, the artist may reject our course as one that seems in all like a road for "losers," for people who cannot get the rewards of winning in the Mainstream "game."

First, it should be admitted that artists who must or want to work deliberately toward wealth and adulation should forget the suggestions offered here. On the other hand, I am not suggesting a deliberate rejection of these attractive things, only a posture focused on doing one's work as one sees fit and doing and offering it where it will serve people well—a posture, then, of withdrawal, not from fame and fortune, but from the concentrated, deliberate seeking thereof. Still, if one will not be content to focus exclusively on his work, but rather must work directly and deliberately toward Stardom, ours is not the Scene for him.

Is this concrete offering of an alternative Scene that of the loser, the person who does not succeed in the Mainstream Scene? Yes, of course; but saying yes is saying nothing much. Winners, whatever may be true of the game they play, seldom seek alternatives to it, because the rewards of winning are usually sufficient to recompense them for their participation. No winners of the Mainstream Game, then, are likely to be among the participants of our alternative game. But my contention is that a truly objec-

tionable game now exists, and this fact necessitates seeking another recourse, though the badness of the situation is being objected to by, of course, the very people most hurt by the objectionable reality. One cannot discredit the objections by calling all the objectors "born losers," inept soreheads, not when we have seen that the "game" is one that *makes* almost everyone a loser because it is defined so as to do so, defined so as to reward "idols," not "professionals." It is a game that inevitably makes losers out of the meritorious *and* the nonmeritorious, since there is no possibility for all the meritorious to be winners. Thus, although it is the losers who are moved to note these bad facts, and not the happy winners, this does not deny the facts or invalidate a search for an alternative "game."

It may be argued that the service motive, which involves the sometimes free proffering of work, denies thereby that the work is valuable, a denial an artist would not want to make. But this is not so if one gives his work only when the call of another great value is heard. The doctor does not deny that medical service is valuable by donating some of his time to free clinics or serving unpaying clients in the ghetto. If one discriminately gives his art work to affect some particular audience or enhance some community, he says in effect, "This movement, institution, or person is good enough for my art and is worth serving through it." He thus establishes, as it were, an equation between things of value, asserting the worth of each and demeaning neither.

Another exception to my suggestion may stem from the belief that nonartists who are deeply involved with art will not find our Scene satisfying, and without these people's support our Scene would be deficient.

It is quite possible that some art people would indeed be disgruntled, and their feelings would be understandable. People such as theorists, curators, critics, teachers, historians, and collectors do whatever they do through the medium of words; on our new Scene, word-usage may be

less called for or even less possible than art people would like. Announcements of "breakthroughs," eliciting much discussion, may be rare, though breakthroughs may happen; titillating talk about Superstars seems unlikely, though exceptionally exciting people may be part of our Scene. Big Events are not likely to be our Scene's specialty, Events to debate over, appear at, or write about, though some important occasions may indeed occur. Then there will be less for some art people to engage through their medium. Surely these deeply involved and caring people will not welcome the promise of lessened engagement to be found in our suggested Scene.

However, while the value of such art people and their efforts must be recognized and their interests respected, we must ask them to weigh their contributions in the balance against the problems caused in part by their activities, and then to see that the result indicates that they be modest in their demands, not having earned the right to be otherwise. For example, they should recognize that some art is privileged over others, and to the detriment of us all, because these forms prompt word usage, that is, because they give art people something to do. For example, a form that presents and illustrates a discussible idea is often seen as preferable to a form that produces only deep feeling and speechlessness, even though the discussible idea is a trivial one and the speechlessness is caused by awesome beauty. If art people understand this situation, they may feel less inclined to think that all art worlds should be made to *their* measure, and they might even aid in this new endeavor despite their inclinations.

It may be objected that I have idealized the university and have not foreseen the difficulties of creating a major portion of our alternative Scene on the campus. Such objections confuse my statements about the university's *potentials* with statements about current reality, but let us note and admit the bases of the objector's doubts: It may be said that college trustees, administrators, and professors are for the

most part Establishment people, who are not likely to support our efforts. Students, too, are often not the counterculturists mentioned, nor are they self-realizers or even studiers, but rather only confused people muddling their way along predesignated paths toward unknown objectives. And even some counterculturists and self-realizers are, despite these orientations, deplorable people—foolish, completely self-centered, and psychologically fouled up. Nonetheless, the potentials cited are there, and the objections only say that there is a big job to be done in realizing these potentials and that success will not be boundless. For while acknowledging the objections, it must also be said that the artists and art people in universities are often the least Establishment-oriented of the faculty; also, many students want art; and these people can either pressure trustees and administrators so as to achieve major implementation of their plans, or, failing in this, they still can proceed within their own limited domains to work toward the Scene they want, for trustees and administrators do not act inquisitively and preventively in every area of endeavor on the campus. And while some students undoubtedly constitute a bad audience for art, the percentage of alert, sensitive, open people in the student population is probably as high as one can find anywhere. After all, we do not need to have the university fully and exclusively permeated by our values and practices to find some place in it for our Scene; we just need it to be pluralistic (and pluralistic it is) enough to house us along with others.

The above objections say we may fail in realizing our aims; other objections indicate fear that we will *succeed* and thereby do bad things to art and American life.

It may be objected that if we succeed we will have created merely another cozy, exclusive Establishment, employing now college-based artists and art people instead of Madison Avenue habitués, to form another mainstream, flowing from campus to campus. And our new Scene may be one that deters children, old people, the poor, and manual

workers—people perhaps made uncomfortable by a college atmosphere. It may be, in all, merely another elite world.

It may be said also that incorporation of the arts into an Establishment institution may rob art of its vigor and bite: too much of the comforts of home will do that.

It may be argued that if we succeed in putting art and artists everywhere, it will make not only for bland art but for cultural pretentiousness and mediocrity.

These dangers are real and important ones, so important that should we fail to avoid or overcome them, our Scene would have to be abandoned.

To consider the easier matters first: though our Scene could become another elite Establishment, it need not. Stipulations to avoid rigidity and control by clique can be written into the Scene at the outset. One can prevent reification, exclusiveness, and dominance by an elite by, for example, dividing the powers for direction of local efforts among various sorts of people, making openness of opportunity a rule, assuring frequent changes in directorates, and the like.

And although new Scene artists could conceivably become elitists, they may also avoid this by some effort and perhaps a little help from their friends.

As for serving a broad audience: if some people (the young or old, or people self-conscious about their lack of education) are put off by the university atmosphere, one can work to modify this atmosphere. And, I repeat, the other locales—stores, union halls, and so on—can well be part of the alternative Scene, and especially should they be in places where the university serves the broader community poorly.

As for the danger that artists may become co-opted, may become domestic cats instead of tigers: the pitfalls of being accommodated too readily, of being disarmed by comfort, are too obvious to deny. One can only hope that artists stay alert to it and overcome the danger. I think we must recognize that there are equal or greater dangers present in the

Mainstream Scene and dangers also in being entirely home-less, without any Scene at all. Speaking to an empty room counters no one's thinking and warps the speaker. One can stay vigilant, can enter the new Scene with the understand-ing that he comes not with conformity and compliance, nor necessarily with a commitment to being contrary, but with an independent and fresh posture, something he will not lose through seduction. If it turns out that generally artists are defeating their art and their reasons for being through participation in the new Scene, they can withdraw from it and pull it down behind them. So, although the dangers in accommodation are real and important, they are not ines-capable or eternally damning.

The danger that our Scene will foster aesthetic medioc-rity and shallow cultural pretentiousness is also a real one for the artist and the public. As for artistic quality, however, there is nothing in our views or in the proposed Scene that directs artists to aim at mediocrity or to be anything less than the best they can be. I took some care to say earlier that not everything one gives as art is aesthetically adequate; it also seems obvious that even adequate offerings may range from the trivial to the profound. A new, wider Scene only means that the range of givens will, most likely, be con-fronted by an equal range of takers. There is nothing in this to tell the artist anything about the type or height of his art-giving ambitions. If he is tempted to work for the greatest number of enthusiasts or to settle for the average of his audience, he might seek a middling quality for his artistic efforts, but such seeking is not warranted by these arguments or implicit in the Scene proposed here.

In spreading art all over, we do increase the possibility of pretensions to Culture by people who may in fact have only a shallow art involvement, and that with low-level stuff. But we can help people understand that pride cannot come from merely being in art—this is no sacred kingdom—but from achieving something in it at some worthwhile level. And we can help people understand that our Scene, in

being widespread, is not alleging that all things and all people are equally sensitive, talented, profound, and intelligent, but rather that people and things of all kinds and levels should be enabled to match up without the interference of theoretic, geographic, or economic barriers. That personal barriers and capabilities will come into play cannot be doubted. If this is understood, people will be less prone to congratulate themselves on being "cultured" merely because involved in art. A risk does exist, but the promise of the Scene makes the efforts and the risks worth the making and taking.

It may also be objected that this alternative Scene cannot really alter the Mainstream Scene, for a large part of the Mainstream is powerful Big Business and will not be affected by our puny efforts. Mere alternatives that do not alter Mainstream conditions must seem insufficient to concerned art radicals. But we must note that the Mainstream enterprise rests on money and a mystique, and our efforts undermine both. That is, the alternative Scene would be committed to getting art goods and services to people at little or no cost (as the case demands) and at outlets all over the country. It would surely have some effect on the Mainstream market to provide conveniently, for little money, that which in that market costs thousands of dollars. The effect would be, one would think, to sap that market of some of its devotees and clientele (as well as profit). In fact, one would think that inexpensive, widely distributed art centers would even decrease the travel to the Big City Scene for art. Further, the Mainstream's very high prices are supported, perhaps largely supported, by the belief that art objects are points of psychic breakthroughs, near-holy quests, historical conquests, and the like, and the above arguments and their manifestation in our new Scene should tend to undermine this price-elevating aura around art objects, and indeed tend to weaken confidence in that whole art world, just as the revolutionist's actions and ideas are already doing. Of course, there will probably continue

to be great artists and great works on the Mainstream Scene, and people continuing to participate—for the great things or just to be part of an elite. But it would seem likely that a decentralizing, deflating effect should still occur, and so justify our efforts to those who want not only an alternative, but a change of the established art world.

But of course, my claim as a change agent is to effectiveness, not full sufficiency. Also necessary are the pressure tactics, protests, demonstrations, coalitions, and so on, that have been and can continue to have their effects on the art world and on art's role in the world. The Scene suggested here obviously is not a replacement for such actions or for groups pushing the cause of Black art or women's art. I am only asserting that my suggestion is a good one, a very good one, taken alongside others.

Making the Scene

Things to do to realize the redefinition and the new Scene are implicit in the above pages. For example, artists can band together to rent vacant shops and make them, tentatively or permanently, into galleries. After all, if what Rauschenberg says is art is indeed art, then what you say is a gallery is indeed a gallery. And what one designates as "gallery" may or may not remain so: where art is, while it is there, is an art show-place. One can also start urging that labor and farmer organizations invite art goods and services into their halls. Also, most emphatically, one can ask this of universities, and on a regular basis. Students' organizations can be contacted by artists, or encouraged to form, to get art onto the campus. Artists themselves can form exhibiting co-ops, to present, as it were, a package—of art, of events, of educational service, and so on—to a possible sponsor, a package that is more attractive, perhaps, than presenting a single artist's work.

One could also publish, by cheap mimeographing, a list of artists in one's geographical area, giving such one-line

ads as "John Doe — 100 Picasso Avenue — abstract paintings — Tues. and Thurs. 4 - 11 and by appointment, 555-212-1212." One can thus help create a guide to the Scene Without Walls, an invisible map of where art can be found, without dealers. The cost per artist per year would be negligible and the list could be widely distributed, reproduced at will elsewhere.

Groups could maintain communication with each other, interchanging their facilities, works, and ideas (taking care, however, that a new cozy, exclusive, and narrow fraternity is not thereby established).

But there is no need to go on with suggestions; people will supply their own. The other Scene can be created, and ideas and conditions and usages of art can prevail on it that are better than those on the Mainstream Scene and better than those of the revolution.

In all, we have observed that the choices open to people involved in art are not simply from among revolution, stasis, and reaction, but also include the possibility of the radical transformation recommended here. Should the positions outlined above prevail, a movement toward greater freedom and a wider range of aesthetic practice will occur, and if we reflect our views in action, a greater spectrum of art will become accessible to a larger number of people. The transformation suggested holds no promise of salvation, but it does reveal a sensible and sound position and ways of expressing that position in the world. It enables the continuing, gratifying, making and taking of art. That would seem to be enough.

Notes

Preface

1. Maker of button is cited as "N. E. Thing co" (pronounced, of course, *Anything Company*). "The N. E. Thing Co. (Iain Baxter, President) specializes in new modes of perception and Visual Sensitivity Information (V.S.I.). The company's ACT and ART Departments issue certificates with photo and documentation of Aesthetically Claimed and Aesthetically Rejected Things, ranging in subject matter from icy landscapes to well-stocked supermarkets, from industrial objects to works of contemporary art. Much of Baxter's work is available through documentation in catalogues and books." Ursula Meyer, *Conceptual Art* (New York: E. P. Dutton & Co., Inc., 1972), p. xiii.

2. Phillip Simpkin, at conference of The Institute for the Study of Art in Education, at Teachers College, Columbia University, May 1971.

3. Jack Burnham's book, *Beyond Modern Sculpture* (see Selected Bibliography), is quoted later, as are some of his articles in *Artforum;* Gregory Battcock is best known, perhaps, for his anthologies, *The New Art* and *Minimal Art* (see Selected Bibliography). See Battcock's "An Experiment with Art in Education," in *Art Education.* (January 1971) and his many articles in *Arts* magazine.

Chapter 1

1. So Morris Weitz argues, and it is significant to note that *Aesthetics Today* is introduced with the statement ". . .The limitation of this anthology is evident in the absence of 'definitive' positions. . . ." *Aesthetics Today,* ed. Morris Philipson, (Cleveland and New York: World Publishing Co., 1961).

2. See statement by Stephen Kaltenbach (quoted by Cindy Nemser) opening chap. 1.

3. See Morris Weitz, "The Role of Theory in Aesthetics" in *The Problem in Aesthetics,* ed. Morris Weitz (New York: MacMillan and Company, 1959).

4. Some of my chief sources on Dada are: *Dada: Art and Anti-Art,* Hans Richter (New York: McGraw Hill, 1965); *The Dada Painters and Poets,* Robert Motherwell (New York: Wittenborn, Schultz, 1951); *Dadas on Art,* Lucy Lippard, ed. (Englewood Cliffs, N.Y.: Prentice Hall, 1971).5.

5. Lucy Lippard on Arp (from *Dadas on Art*): "His own work was by then entirely abstract and he was developing his collages of colored paper 'according to the Laws of Chance because it embraces all laws and is unfathomable like the first cause from which all life arises, can only be experienced through complete devotion to the unconscious. I maintained that anyone who followed this law was creating pure life'." Note identification of chance as a life-principle on p. 21.

6. My view here is a resumé and paraphrase of part of Karl Jaspers's *Truth and Symbol,* trans. J. T. Wilde, W. Kluback, and W. Kimmel (New York: Twayne Publishers, 1959).

7. See *Assemblage, Environments, and Happenings* by Allen Kaprow (New York: Harry N. Abrams, Inc., 1966) and "Pinpointing Happenings" by Kaprow in *Art News,* (Oct. 1967).

8. See *The Theory of the Avant Garde* by Renato Poggioli (Cambridge, Mass.: Harvard University Press, 1968).

9. Jack Burnham, "Unveiling the Consort," Part II, *Artforum* (April, 1971), p. 42: "In 1912 Marcel Duchamp discovered that all works of art conform to five types of sentence structure: A) simple sentences B) compound, complex and ambiguous sentences C) 'ready-made utterances' D) elliptical sentences and E) sentences with some disagreement between subject and predicate. . . ."

10. See note 3 above for Weitz's views, and *Man's Rage for Chaos,* by Morse Peckham (Philadelphia: Chilton Books, 1965).

11. *One Dimensional Man* (Boston: Beacon Press, 1964) is probably Marcuse's best statement on this theme.

12. See *Eros and Civilization,* Herbert Marcuse (Boston: Beacon Press, 1955).

13. See Sigmund Frued, "Neurotic and Artist," in *The Problems of Aesthetics,* ed.

Eliseo Vivas and Murray Krieger (New York and Toronto: Rinehart & Co., Inc., 1953) p. 161-62.

14. See Herbert Marcuse on Art as exemplar, chapter 2 in his *An Essay on Liberation* (Boston: Beacon Press, 1969).

15. See Jack Burnham's article "Unveiling the Consort," Parts I and II in *Artforum* (March and April 1971).

16. In *Art Education* (January 1971), p. 11, Gregory Battcock writes in "An Experiment with Art in Education."

> Recent developments in contemporary art—sometimes termed "conceptual art," "street works" and "anti-art"—have insisted upon vague and subtle manipulations of man-made or natural environmental phenomena that sometimes result in art documents that are barely distinguishable from the ordinary environment. . . .It's also important that no "object" remains to be dealt with later. The work can not be marketed, saved or possessed in a conventional sense.

17. Tom Halsall, at Teachers College, Columbia University, N.Y., beginning March 15, 1971.

18. Phillip Simpkin at conference of the Institute for the Study of Art in Education, at Teachers College, Columbia University, May 1971.

19. See *Conceptual Art* by Ursula Meyer (New York: E. P. Dutton Co., 1972).

Chapter 2

1. Says DeWitt H. Parker:

> To find the motivation of a point of view is not to refute it; and no theory is ever held for long by serious men, or recurs again and again in the history of thought without some evidence in its favor. The student of aesthetic theories who watches the rhythmic reappearance of opposing ideas learns to look for the facts covered by each, and to draw the moral that none was wrong but only inadequate.

"The Nature of Art," in *The Problems of Aesthetics,* ed. Eliseo Vivas and Murray Krieger (New York and Toronto: Rinehart & Co., 1953).
And say historians of aesthetics Katherine E. Gilbert and Helmut Kuhn:

What then do art and beauty mean? After submitting to the discipline of history the authors must say: This meaning is not within the four corners of any one or two propositions but it is that fullness of significance which distills from the long-sustained process of all the definings.

A History of Aesthetics (Bloomington, Ind.: Indiana University Press, 1954).

2. The phrase is, of course, the formulation of Marshall McLuhan in *Understanding Media* (New York: McGraw Hill, 1965).

3. See note 15 of chapter 1 above.

4. A basic source in this area is Rudolph Arnheim's *Art and Visual Perception* (Berkeley, Calif.: University of California Press, 1954).

5. I am using here language for art phenomena derived from Edmund Husserl, *Ideas: General Introduction to Pure Phenomenology,* trans. N.R.B. Gibson (London: George Allen and Unwin, Ltd., 19412). The idea of psychic distance is most associated with Edward Bullough, "Physical Distance as a Factor in Art and an Aesthetic Principle," *British Journal of Psychology,* 5 (1912).

Selected Bibliography

Books

Arnheim, Rudolph. *Art and Visual Perception.* Berkeley Calif.: University of California Press, 1954.

Battcock, Gregory. *The New Art.* New York: E. P. Dutton & Co., Inc., 1966.

————. *Minimal Art.* New York: E. P. Dutton & Co., Inc., 1968.

Burnham, Jack. *Beyond Modern Sculpture.* New York: Braziller, 1968.

Gilbert, Katherine E., and Kuhn, Helmut. *A History of Esthetics.* Bloomington, Ind.: Indiana University Press, 1954.

Husserl, Edmund. *Ideas: General Introduction to Pure Phenomenology.* Translated by W. R. B. Gibson. London: George Allen and Unwin, Ltd., 1931.

Jaspers, Karl. *Truth and Symbol.* Translated by J. T. Wilde, W. Kluback, and W. Kummel. New York: Twayne Publishers, 1959.

Lippard, Lucy. *Dadas on Art.* Englewood Cliffs, N.J.: Prentice Hall, 1971.

Marcuse, Herbert. *Eros and Civilization.* Boston: Beacon Press, 1955.

———. *One Dimensional Man.* Boston: Beacon Press, 1964.

———. *An Essay on Liberation.* Boston: Beacon Press, 1969.

McLuhan, Marshall. *Understanding Media.* New York: McGraw Hill, 1965.

Meyer, Ursula. *Conceptual Art.* New York: E. P. Dutton & Co., 1972.

Motherwell, Robert. *The Dada Painters and Poets.* New York: Wittenborn, Schulz, 1965.

Peckham, Morse. *Man's Rage for Chaos.* Philadelphia: Chitton Books, 1965.

Philipson, Morris. *Aesthetics Today.* Cleveland and New York: World Publishing Co., 1961.

Poggioli, Renato. *The Theory of the Avant-Garde.* Cambridge, Mass.: Harvard University Press, 1968.

Richter, Hans. *Dada: Art and Anti-Art.* New York: McGraw Hill, 1965.

Vivas, Eliseo and Krieger, Murray. *The Problems of Aesthetics.* New York and Toronto: Rinehart & Co., Inc., 1953.

Weitz, Morris. *Problems in Aesthetics.* New York: MacMillan and Co., 1959.

Watts, Alan. *Does It Matter.* New York: Random House, 1970.

Periodicals

Battcock, Gregory "An Experiment with Art in Education." *Art Education.* Journal of the National Art Education Association *(January 1971)*.

Bullough, Edward "Physical Distance as a Factor in Art and an Aesthetic Principle." *British Journal of Psychology* 5 (1912).

Burnham, Jack "Unveiling the Consort," Parts I and II *Artforum* (March and April 1971).

Kaprow, Allen "Pinpointing Happenings." *Art News* (October 1967).

Index